Dr. William L. Stephens

DEPRESSION

Successfully Overcoming Depression
and Other Emotional Problems

DEPRESSION: SUCCESSFULLY OVERCOMING DEPRESSION AND OTHER EMOTIONAL PROMBLEMS
Copyright ©2025 Dr. William L. Stephens

978-1-998815-32-6 Soft Cover
978-1-998815-33-3 E-book

Printed in Canada and the USA

Published by:
Castle Quay Books
Little Britain, Ontario, Canada
Jupiter, Florida, USA
Tel: (416) 573-3249
E-mail: info@castlequaybooks.com | www.castlequaybooks.com

Edited by Marina Hofman Willard PhD
Cover design and book interior by Burst Impressions

All rights reserved. This book or parts thereof may not be reproduced in any form without prior written permission of the publishers.

Scriptures are taken from the Holy Bible, New International Version®, NIV® Copyright ©1973, 1978, 1984, 2011 by Biblica, Inc.® Used by permission. All rights reserved worldwide. • Scripture quotations marked (GNT) are taken from the Good News Translation® (Today's English Version, Second Edition) Copyright © 1992 American Bible Society. All rights reserved.• Scripture quotations marked (NLT) are taken from the Holy Bible, New Living Translation, copyright © 1996, 2004, 2015 by Tyndale House Foundation. Used by permission of Tyndale House Publishers, Inc., Carol Stream, Illinois 60188. All rights reserved.• Scriptures marked (CEV) are taken from the Contemporary English Version Copyright © 1995 by American Bible Society. Used by permission. • Scripture quotations marked (TLB) or "The Living Bible" are taken from the Living Bible / Kenneth N. Taylor. Wheaton: Tyndale house, 1997, ©1971 by Tyndale House Publishers, Inc. Used by permission. All rights reserved. • Scriptures marked (KJV) are taken from the Holy Bible, King James Version, which is in the public domain.

This is a work of fiction. All incidents and dialogue, and all characters with the exception of some well-known historical figures, are fictional or have been adapted for dramatic purposes. Where real-life historical figures appear, the situations, incidents, and dialogues concerning those persons are entirely fictional and are not intended to depict actual events. In all other respects, any resemblance to actual persons, living or dead, events, or locales is entirely coincidental.

For Library of Congress Cataloging Information please contact the publisher.

For Library and Archives Canada Cataloguing in Publication Information please contact the publisher.

MY STORY

I CANNOT REMEMBER ever doubting or challenging what I learned about God. It was not until later in life that I had questions about my faith and salvation. I was introduced to Jesus Christ and the Bible as a child through family devotions and church. I never missed Sunday services unless I was sick. After graduating from high school, I left home to attend Florida State University, relatively secure in what I had been taught academically and spiritually.

Regrettably, I did not begin reading Scripture until my junior year of college when my girlfriend gave me my first Bible as a birthday present. I read it occasionally so she and my conscience would both be happy. I remained interested in my faith, probably because many of my friends were Christians. The atheistic influence of woke professors and the rhetoric of communist activists on campus never lured me away from my parental influences. But I never grew significantly in my faith. I grew spiritually only after I graduated with my doctorate and began my lifetime career as a college professor. At that time, I became involved in a local church and its many activities.

As the Bible gradually became an essential part of my life, I became more active in my academic, professional, and spiritual communities. I did believe in Jesus as Lord and Savior, but for some unknown reason, I still lacked confidence in my eternal salvation. I struggled to accept that my faith was genuine. Because of my insecurity, I was never willing to give

a testimony about my faith. I felt confident that no one would be inspired by a Christian who had doubts about salvation, nor one who never had a moment when a miracle changed his or her entire life.

I considered those who shared their story to be terrifically brave. They did not doubt God's intervention in their lives. What they shared was not only credible but also exciting. I wanted what they had! I would join the congregation in worship by showing appreciation to the Lord with thanks, praise, and adoration. However, I sometimes cringed with jealousy as I saw others confident about their faith. I never wanted anyone to ask me about my story of faith, a faith I was still unsure of. Who would even care about my story? Wouldn't they conclude that my faith was simply the inherited faith of my parents?

Eventually—and thankfully—God did show me that my gradual development of faith—a story of advancing faith—was the story experienced by many Christians. And, like me, they were often afraid to admit it.

MY PATH

AS I GREW spiritually, I craved spiritual fireworks, as my friends had experienced, that had not yet materialized in me. As I look back, however, I see that what occurred in my life was a variety of essential steps that I now recognize as significant. As years passed in my walk of faith, I started referring to these steps as "my spiritual growth spurts." Each represented a new, exciting, maturing, and powerful experience that continually brought me closer to the Lord. A few of these include becoming the leader of a long-running home Bible study, assuming leadership roles in church Bible studies, taking a sabbatical from my position to teach at a predominantly Black university, serving at numerous church construction projects for Native Americans, and cleanup projects for hurricane disasters. Each event added meaningful growth to my walk of faith and love for the Lord.

Looking back, I regret not sharing doubts about my faith early on with a few close Christian friends. They could have helped me put my fears to rest and soothe my soul. Instead, my soul's complete peace was delayed until I experienced a horrifying bout with depression. It was as though all the negative experiences throughout my life came to a climax, leaving me clinically and spiritually depressed. I realized later that although it was the worst experience of my life, it became one of the absolute best experiences I ever had *for* my life. Let me explain ….

During my depression, I took a hard look at myself and realized that there could not be *testimony* without tests. Trials purify faith because a faith that is tested is a faith that can be trusted. I failed to realize that my faith had been there all along. Satan had been the perpetrator and source of my doubts all along. Depression took me to my knees so God could bring clarity for me to recognize my faith as stronger than Satan's lies, deceptions, and perversion of the truth. God assured me I had passed His test and could fight hellish fire with God's truth. Satan was destined to lose the battles in this spiritual war for my well-being. God fights for me! God loves me! I am a child of God!

Although I never turned away from God, doubted Him, or blamed Him, I often cried out to Him for help. I have learned to align myself with God, and He will fight on my behalf. He loves me unconditionally.

Now, I am ready to share my testimony. My salvation had been sealed long ago, and God showed it to me through my unrelenting faith. He is always on my side, fighting for me. He became the foundation block for everything in my life.

As Paul tells us in Romans, God always works for our good.

> We know that in all things, God works for the good of those who love Him, who have been called according to his purpose. (Romans 8:28)

When bad things happen, if you love and trust the Lord, God will let you experience abundant good coming from the bad. When I was first diagnosed with severe depression, I realized the importance of completely turning my problems over to the Lord. Within a week, I started receiving blessings from various directions—blessings I still enjoy.

In the years that have passed, I have learned to employ the verses in this booklet to help me control my emotional issues and point me toward God's blessings. An important lesson I have learned is that no one can expect God to protect them from demonic influences if they fail to take an

active part in their defense. Using God's Word against evil is the essence of taking a proactive stance!

WE LIVE IN CRITICAL TIMES

I BELIEVE THIS moment in history is the perfect time to address the dilemma of depression seriously before it is too late. This is because there has never been a more critical and dangerous time. Depression and other emotional issues have reached an all-time high in terms of frequency and severity. This is especially true for the next generation, and mental health specialists are sounding the alarm. Young people are experiencing significant increases in emotional challenges that are leading to dire increases in suicides.

Why Now?

WHAT HAS HAPPENED to us and our country during the last few years puts us all in greater jeopardy. Much of this has been closely associated with the COVID-19 pandemic. We are in troubled times, and it is no wonder that depression and other emotional issues are running rampant. We all need help, but most do not know where to look. Much of this deterioration began with COVID-19. We lived through a time of widespread sickness and death, endless shutdowns, misleading information, and resulting fears that paralyzed our great country. Subsequent consequences included the loss of faith in our leaders, the attacks on our faith and family values, the loss of jobs, skyrocketing inflation, rioting in the streets, and an increase in crime.

We now fear for our safety in the streets, neighborhoods, and subways, the defunding of police, and the massive release of dangerous prisoners. On a larger scale, we now face wars and rumors of war in all corners of the world, with open borders for illegal immigrants, drugs, and murdering cartels. Once again, we have a weakened military, continuous loss of constitutional rights, international deterioration of respect and cooperation, and the rapid likelihood of a new world order.

The education system is now a significant concern for many parents. Teachers and administrators promote porn through reading assignments, host vulgar presentations, and run gender identity programs without inform-

ing parents. Parents who have aggressively protested have been ignored, attacked, investigated, and even arrested for being domestic terrorists.

Our kids are being left behind educationally and may never recover. Common sense says that this results in skyrocketing depression and many other emotional problems in every American family. There are not enough MDs, psychologists, psychiatrists, and mental health specialists to help all who will need help.

Our God, however, can deal with every/any problem of every person who suffers. He provides simple and precise advice, suggestions, and encouragement throughout His Word, which is lovingly known as the Bible. This booklet offers an excellent sampling of verses that relate to overcoming depression and other emotional problems, no matter how old or educated you are.

COVID-19 IS OVER! WHY PANIC NOW?

WHY WORRY NOW? Isn't COVID-19 over? Can't we go back to our everyday lives? Won't all the terrible events be forgotten as we return to normal? Does Covid even have a direct impact on many of these emotional triggers?

Unfortunately, our government is unlikely to change. New COVID strains are predicted. New vaccinations are already in production. New laws, orders, and controls for our country are most likely in the planning stages.

A critical issue is the correlation between COVID-19 (and other strains) and depression and other serious emotional problems. If there is a direct link, then the next pandemic is predicted to have a cumulative impact on those who have already experienced depression and an initial impact on those who had previously avoided it.

Here are some up-to-date facts about the relationships between COVID and severe emotional problems. When the virus infects you, your immune system is weakened by things that promote inflammation. If the body cannot control inflammation, a more severe virus or a new virus attacks the body. This is likely to result in new or more significant depression, especially for younger patients.

In light of this, it is essential to seek God's assistance.

WHY DO I SHARE?

I SHARE MY personal story with you because I want you to trust me as we discuss complicated issues during difficult times. I want you to consider that we may all have some emotions and goals in common so that whatever I have learned, utilized, and share with you now can be as valuable to you as well. Second Corinthians 4:8–9 perfectly reflects how I felt twenty years ago and, to a much lesser degree, even today at times. The passage refers to being troubled, in doubt and despair, having enemies, and being without a friend and badly hurt.

If this were all that the Bible included in these verses, it would be bleak for all of us. There would be no hope. However, with God, we have hope and Good News.

> We are often troubled but not crushed; sometimes in doubt but never in despair; there are many enemies, but we are never without a friend, and though badly hurt at times, we are not destroyed. (2 Corinthians 4:8–9 GNB)

God promises—guarantees—that if you embrace the verses introduced and explained in this booklet, you can avoid being crushed, in despair, without a friend, and destroyed. I embraced these verses twenty years ago, and I still do today. I encourage you to welcome them as well.

PURPOSE

AS YOU KNOW, my problem is depression. When you examine the symptoms that signal depression, the more symptoms you experience, the higher the likelihood you suffer from this problem. When you examine the list of symptoms, you will find that most are rooted in these common emotions: hate, anger, fear, anxiety, pride, pleasure, envy, discouragement, irritation, sadness, disgust, lust, and misery. As I evaluate this list today, I realize that my depression, at some time or another, involved each one of these. Therefore, I now conclude that depression—for many or most of us—is not due to or caused by a single emotional weakness. I now believe that depression, in its simplest form, is significant suffering from numerous unhealthy emotions. For me, fears were probably my worst emotions, but anger, sadness, pride, misery, and others were all close behind.

To make this clear, many emotions are not necessarily evil, especially if they are temporary, moderate, and kept under control. They can even be good and healthy, but only if used correctly and for a good purpose. However, when emotions are long-lasting, unhealthy, extreme, and out of control, it is time to be concerned and seek help. The same can be said when you have few or no emotions—basically, you become an automaton. It is all about balance.

When any of your emotions are out of control, there is one thing you should never do. You should never suffer alone. While many friends and

counselors might be glad to help you and possibly be helpful, there is only one perfect adviser. It is God! You will always succeed when you go to Him first and follow His advice. You will then start experiencing a closer walk with God.

> Come near to God and he will come near to you. Wash your hands, you sinners, and purify your hearts, you double-minded. (James 4:8)

When you walk in step with God, you can feel His presence and begin to learn more about who He is. Dealing with your emotions with help will assure you of greater peace, confidence, joy, and wise decision-making.

POSITIVELY CONTROLLING OUR EMOTIONS

THE PREVIOUS SECTIONS of this booklet introduce the concept of walking close to God. Every negative emotion we fail to control can lead to results that take us away from closeness to God and make it difficult to have loving, joyful, healthy, and meaningful lives. It results in our pulling away from God. To help prevent this repercussion and draw closer to God, each section of verses introduced here offers biblical suggestions for positively controlling our emotions. Taking God's wise advice can lead us to regain control of our lives.

The first major section looks at the qualities God wants us to develop so we can have a close enough relationship with Him to benefit from the blessings He provides as we deal with our negative emotions. These include learning how and why to communicate through prayer, surrendering our heart and soul to Jesus, following in Jesus's footsteps in submission, embracing forgiveness when given and received, and loving those God loves and wants us to love. Practicing these verses will get us back in touch with God.

The second section introduces spiritual tools for godly protection that assist us in our struggles with our powerful enemies. You will learn how to use God's armor, power, light, and safe spaces to overcome fears, pride, and all other negative emotions.

Before you dive into this section, I'd like to offer a few valuable suggestions for your trip.

1. Read the whole section from beginning to end for an overview.

2. Use God's wisdom to say a short prayer to give each suggestion a fair chance before deciding which suggestions to use and which to leave.

3. As you read, categorize each section with one to five asterisks (* to *****). The order you assign to the asterisks can be based on how you feel you can emotionally deal with them. One order could be ranking them from the easiest to the hardest. I call this "Start Slow and Build Up". Or the order can be from most challenging to easiest, which I call "Go for It."

4. You might not classify them at all. You may decide to use their order in the book. You can start with the section on prayer and continue chronologically to the end. I have made a significant effort to connect each section to transition meaningfully and clearly.

5. After reading the entire section, reexamine each subsection in greater detail. When you get to the verses associated with text that precedes the verse(s), try first to understand the relationship of the verses to the section at hand. Use a highlighter to identify the verses you think you can utilize later. I ask you to also consider memorizing the verses you identify.

6. To memorize them, look at one verse at a time. Let's say it is "For God so loved the world that he gave his one and only Son" (John 3:16). This translation, NIV or New International Version, is one of many Bible translations. I chose verses from translations I felt were most straightforward to relate to the discussed issue.

7. The techniques used to memorize verses can differ significantly. Mine is simply this. Stare first at the verse reference. Keeping your eyes on the reference, say the reference out loud five to ten times. Now, stare at the verse and carefully read aloud the entire verse the same number of times. You can do this one verse at a time or the whole passage simultaneously if there are multiple verses. I prefer one at a time. Unless the verses are immediately deeply embedded in your brain, you will need to return each day and repeat the process until they are permanently remembered.

COMMUNION WITH GOD

WALKING CLOSE TO God requires consistent prayer in our daily lives. Several habits can help you with your walk with God. They include but are not limited to daily prayer and Bible reading. These provide the foundations for your faith and help you get the most out of this booklet. There are many verses here for your new journey. With prayer, you can maximize the benefits you derive from your understanding and personal application of these verses.

Prayer can be pretty straightforward. It is direct communication with God. God tells us to come to Him whenever we are in need, no matter the reason or the time. Direct access to God in prayer is an honor and should be used continuously.

> Don't worry about anything; instead, pray for everything. Tell God what you need, and thank him for all he has done. (Philippians 4:6 NLT)

> We are confident that he hears us whenever we ask for anything that pleases him. And since we know he hears us when we make our requests, we also know he will give us what we ask for. (1 John 5:14–15 NLT)

An excellent way to study, learn, and apply the verses in this booklet is to make them part of your daily prayer time. The verses can be integrated into prayers that praise God, seek His forgiveness, intervene for others, and thank God for blessings and answered prayers. The closeness you receive from your God assures you of His understanding, love, and protection.

Your prayers can be used to seek God's wisdom in selecting the best verses for you to embrace. Some verses may be on point for your situation, and others may not. If asked, God can help you decide which verses are most relevant and how to utilize them. For those verses, God will help you fully understand each one's relevance to your situation and recall them when you need their assistance.

SURRENDER, SUBMIT, TRUST

OUR CLOSE WALK with God must begin with salvation, a choice I hope you have already made. When we surrender our hearts to Jesus, we are saved for all eternity:

> It is by grace you have been saved, through faith—and this is not from yourselves, it is the gift of God—not by works, so that no one can boast. (Ephesians 2:8–9)

> The Son of Man came to seek and to save the lost. (Luke 19:10)

Romans tells us how the following act of confession can achieve this relationship with God and provide you with the blessing of confidence.

> If you declare with your mouth, "Jesus is Lord," and believe God raised him from the dead, you will be saved. For it is with your heart that you believe and are justified, and it is with your mouth that you profess your faith and are saved. (Romans 10:9–10)

At this very moment, we are saved from the penalty of sin. We are set free of sin. We are bound for heaven.

> It is for freedom that Christ has set us free. Stand firm, then, and do not let yourselves be burdened again by a yoke of slavery. (Galatians 5:1)

Once we are saved from the penalty of sin and guaranteed a place in heaven, we can look forward to being set free from the power and presence of sin. We have just started the great adventure that leads to walking closer to God and benefiting from all the other promises of the Bible.

Now, we must submit ourselves to God. Submission requires us to diminish ourselves by giving up our desires, hopes, and wants in return for following Jesus wherever He leads us. And we do this by listening, obeying, and following Him.

Jesus and James instruct us:

> Whoever wants to be my disciple must deny themselves and take up their cross daily and follow me. (Luke 9:23)

> Submit yourselves, then, to God. Resist the devil, and he will flee from you. (James 4:7)

We must depend on God's power and resources to accomplish this and trust Him wherever He wants to take us.

> Trust in the LORD with all your heart and lean not on your own understanding; in all your ways submit to him, and he will make your paths straight. (Proverbs 3:5–6)

> When I am afraid, I put my trust in you. In God, whose word I praise—in God I trust and am not afraid. What can mere mortals do to me? (Psalm 56:3–4)

GOD FORGIVES US SO WE CAN FORGIVE OTHERS

TAKING THE FIRST few steps of surrender and submission to God leads to a closer walk with God but does not necessarily free you from hurtful emotions. You will most likely continue to experience hurt when interacting with others. Hurtful feelings can be challenging to forgive. God set the tone for us by forgiving us for all our sins that sent Jesus to the cross. The Bible tells us:

> If we confess our sins, he is faithful and just and will forgive us our sins and purify us from all unrighteousness. (1 John 1:9)

> He has rescued us from the dominion of darkness and brought us into the kingdom of the Son he loves, in whom we have redemption, the forgiveness of sins. (Colossians 1:13–14)

Because of God's absolute love for us, He is willing to forgive anything offensive we do against Him and wants us to follow His example. God expects us to extend the same forgiveness to those who trespass against us—an essential element of the Lord's Prayer. Not only does the Lord tell

us to forgive others in the Lord's Prayer, but He also uses forgiveness as a criterion for being forgiven.

> If you forgive other people when they sin against you, your heavenly Father will forgive you. (Matthew 6:14)

> When you stand praying, if you hold anything against anyone, forgive them, so that your Father in heaven may forgive you your sins. (Mark 11:25–26)

Please realize that failing to forgive others does not mean you will not go to heaven. You have already been saved, and that cannot change. These verses indicate that we face difficulties and the consequences of these difficulties here on earth. For example, failing to forgive others can cast a dark cloud over us, and an emotional storm of distress may surface.

These verses teach us that an unrepentant lack of forgiveness can carry over to the appointed time when we Christians must appear before the judgment seat of Christ, where Jesus evaluates our good and evil works. The verses on God's unforgiveness in Mark 11:25–26 refer to the judgment that occurs after we die. The Bible also teaches:

> We make it our goal to please him, whether we are at home in the body or away from it. For we must all appear before the judgment seat of Christ, so that each of us may receive what is due us for the things done while in the body, whether good or bad. (2 Corinthians 5:9–10)

> By the grace God has given me, I laid a foundation as a wise builder, and someone else is building on it. But each one should build with care. For no one can lay any foundation other than the one already laid, which is Jesus Christ. If anyone builds on this foundation using gold, silver, costly stones, wood, hay or straw, their

work will be shown for what it is, because the Day will bring it to light. It will be revealed with fire, and the fire will test the quality of each person's work. If what has been built survives, the builder will receive a reward. If it is burned up, the builder will suffer loss but yet will be saved—even though only as one escaping through the flames. (1 Corinthians 3:10–15)

As Christians, we are already assured of heaven. Even though our works on earth do not impact our certainty of salvation, they determine the rewards, blessings, treasures, and responsibilities we will be given later.

Look, I am coming soon! My reward is with me, and I will give to each person according to their actions. (Revelation 22:12)

This refers to the judgment that all Christians must face based simply on their works. It evaluates all our deeds on earth—good and bad—and I believe it is based only on our new life that starts at the moment of salvation.

You may need to ask God, your Creator, to forgive you for the resentment you have harbored against Him. You may be angry and even hurt that God has not yet relieved you of the struggles you are going through or the challenges of a situation you face. Your response may be to blame God for your circumstance. If you do have hard feelings toward God, tell Him in prayer. God will appreciate your confession, and you will feel a great relief. Be sure you understand that God never sins, and He always works for your good, even when you struggle to see the good in your situation.

One last thing about forgiveness is an excellent insight I realized at a very late age. Be sure to forgive yourself because you are the one with whom you are sometimes disgusted or most disappointed. It may be more complicated than you think—it was for me. For that reason, I suggest you do it out loud. I say this because the first time I did it, it took me ten

minutes to get the words out of my mouth. But when I finished, it felt like a massive weight had been taken off my shoulders.

Remember this: when God created everything that exists, He spoke each of the six days into existence. Of course, He could have thought everything into existence, but He did not. I believe God does and did everything with a purpose.

LOVE GOD, YOURSELF, AND YOUR NEIGHBOR

WHEN YOU EXPERIENCE difficult emotions, there are people you may have forgiven but still cannot love. You are too hurt, and you feel they are undeserving. Jesus loved the Pharisees who sent Him to the gallows and the soldiers who nailed Him to the cross. He loves every person who rejects Him and the opportunity to spend eternity with Him in heaven. He also loves those who have hurt you and wants you to love them in return.

The Bible tells us that God loves beyond imagination and that He is love!

> God is love, and those who live in love live in union with God and God lives in union with them. (1 John 4:16 GNT)

This One God, who is love, also loves you personally and anyone you may still hold a grudge against.

> See what great love the Father has lavished on us, that we should be called children of God! And that is what we are! (1 John 3:1)

> This is how God showed his love among us: He sent his one and only Son into the world that we might live through him. (1 John 4:9)

This God, who always loves us, desires us to love Him in return.

> Jesus answered: "Love the Lord your God with all your heart, soul, and mind. This is the first and most important commandment." (Matthew 22:37–38 CEV)

Matthew 22:39 adds a second important commandment of love to humanity. It adds two additional people whom we are encouraged to love.

> "The second most important commandment is like this one. And it is, 'Love others as much as you love yourself.'" (Matthew 22:39 CEV)

This CEV translation tells us to love others, while most other translations use the word "neighbor." Either way, this command includes the families at home, friends next door and down the street, and anyone we meet anywhere. And 1 John says further that only when we do love one another can His love be made perfect in us.

> Dear friends, if this is how God loved us, then we should love one another. No one has ever seen God, but if we love one another, God lives in union with us, and his love is made perfect in us. (1 John 4:11–12 GNT)

Returning to Matthew 22:39, we read, "Love others as much as you love yourself." This makes it clear that God is all-inclusive in directing us to love Him, others, and ourselves humbly.

DEALING WITH FEARS

MY DETERRENT TO walking close to God was the evil influence of fearfulness in my life. The enemy knew precisely how to use my fears to disrupt my life. It was my most significant roadblock to good health. And it was also probably the cause of my earlier spiritual doubts. When my two greatest fears—rejection and failure—were first identified in a session with my therapist, I was shocked and defensive. However, after a discussion with my therapist, I knew she was correct. I needed help! I started on my road to recovery, which put me on a journey to identify everything I might fear. I even kept a list of my fears (that eventually reached fourteen items) on my desk at work so I would not forget.

God is very clear about fear. He does not want it in our lives and has written many verses to help us.

> "Do not fear, for I am with you; do not be dismayed, for I am your God. I will strengthen and help you; I will uphold you with my righteous right hand." (Isaiah 41:10)

> "I am the LORD your God who takes hold of your right hand and says to you, Do not fear; I will help you." (Isaiah 41:13)

Several years later, I learned something else about fears. For some of them, God demands that we fear as well. This is the fear/respect of God

Himself. These fears lead us to a strong faith in God, who supplies all our needs. Failure to fear God leads to unbelief and mistrust.

> Fear of the LORD is a life-giving fountain; it offers escape from the snares of death. (Proverbs 14:27 NLT)

> Reverence and fear of God are basic to all wisdom. Knowing God results in every other kind of understanding. (Proverbs 9:10 TLB)

Most of our fears come about because we do not trust God with our lives and all the decisions we need to make. We forget to go to God for assistance but turn instead to ourselves. In essence, we reject God's magnificent role in our lives. These fears lead us away from God and are sinful.

> [Jesus] asked them, "Why were you so fearful? Don't you even yet have confidence in me?" (Mark 4:40 TLB)

> For the fearful, and unbelieving, and the abominable, and murderers, and whoremongers, and sorcerers, and idolaters, and all liars, shall have their part in the lake which burneth with fire and brimstone: which is the second death. (Revelation 21:8 KJV)

Cleansing our minds of fears should be a priority. Without fears—and thereby less sin—we can walk closer to God.

GOD'S POWER AND PRAISE

THE OXFORD DICTIONARY defines power as "the capacity to direct or influence the behavior of others or the course of events." Although power can be used for good, it can be hazardous when it is in the wrong hands—such as Satan's. Only God can use power entirely for good, but He does trust some of us to utilize power when we are under the control and direction of the Holy Spirit to fight and hopefully defeat evil.

God's power is needed by those seeking help with emotional issues. God provides power to us in many ways: the power of the Holy Spirit, the power of the Word of God, the power of the blood of Christ, the power of prayer, and the power of Christ's intercession.

> When Jesus had called the Twelve together, he gave them power and authority to drive out all demons and to cure diseases. (Luke 9:1)

> Your right hand, Lord, was majestic in power, your right hand, Lord, shattered the enemy. (Exodus 15:6)

The power God gives us can be used very effectively against Satan and his demons. The easiest way to implement it quickly is to use the power and authority of Jesus's name against Satan in prayer. When we invoke the

name of Jesus, we remind the enemy of the power that we now have and of the authority to employ that power because Jesus has delegated it to us.

> I will remain in the world no longer, but they are still in the world, and I am coming to you. Holy Father, protect them by the power of your name, the name you gave me, so they may be one as we are one. (John 17:11)

> Whatever you do, whether in word or deed, do it all in the name of the Lord Jesus, giving thanks to God the Father through him. (Colossians 3:17)

Using the name of Jesus against Satan can be optimized while praising Jesus verbally. You see, Satan fears Jesus, and he fears every mention of Jesus. It is a clanging gong to him. So whenever we praise Jesus out loud, Satan is afraid of us as well.

> Praise be to the name of God for ever and ever; wisdom and power are his. (Daniel 2:20)

> Sing the glory of his name; make his praise glorious. Say to God, "How awesome are your deeds! So great is your power that your enemies cringe before you. All the earth bows down to you; they sing praise to you, they sing the praises of your name." (Psalm 66:2–4)

For me, I say the words "Praise Jesus!" Lifting the name of Jesus in praise is a terrific way to think about Satan's response. Praise silences our enemy; praise is the means by which God shuts the mouth of the enemy.

Satan is significantly weakened! Take advantage of it by yelling Jesus's name to the heavens.

BE IN THE LIGHT OF JESUS

ANOTHER EXCELLENT PROTECTION God promises us is that we may reside in the light of Jesus. Evil hides in darkness, waiting to attack us in many ways. We cannot live very well in the darkness, however. We cannot see, move, or fight evil in us. If we live in the light of Jesus, however, evil will not enter and, therefore, cannot have any influence, or it will flee when the light of Jesus is turned on.

> When Jesus spoke again to the people, he said, "I am the light of the world. Whoever follows me will never walk in darkness but will have the light of life." (John 8:12)

> The Word gave life to everything that was created, and his life brought light to everyone. The light shines in the darkness, and the darkness can never extinguish it. (John 1:4–5 NLT)

Remind Satan that Jesus lives within you, and His light shines brightly. This light will not accept Satan's presence. If you cannot detect His light within yourself, simply ask Jesus for it, and He will provide.

GOD SURROUNDS US WITH SAFE SPACES

ANOTHER WAY OF finding peace from Satan is to ask God for one or more of His "safe spaces." Numerous examples in the Bible demonstrate how God will place spiritual barriers to separate and surround us from the attacks of Satan and his demons. I love to visualize these in my mind. I imagine their literal existence and picture God's protection as it is described in the Bible—a hedge, a shelter, a fortress, an angel, and a wall of fire. He wants us to ask and pray for this protection.

> "Have you not put a hedge around him and his household and everything he has?" (Job 1:10)

> Whoever dwells in the shelter of the Most High will rest in the shadow of the Almighty. I will say of the LORD, "He is my refuge and my fortress, my God, in whom I trust." (Psalm 91:1–2)

> The angel of the LORD encamps around those who fear him, and he delivers them. (Psalm 34:7)

> "I myself will be a wall of fire around it," declares the LORD, "and I will be its glory within." (Zechariah 2:5)

PUTTING ON THE ARMOR OF GOD

IN THE TIME of Jesus, Rome's control over three million square miles of territory was greatly attributed to the success of its army. Roman leaders were the best of the best. Roman soldiers were the bravest, the best trained, and the best equipped in the world. Paul used the image of a Roman soldier and his clothing and weapons as an example to demonstrate the protection Christians can have when defending themselves against their greatest enemies—Satan and his followers.

In Ephesians 6, Paul encourages Christians to put on the armor of God—another "safe space"—as their daily protection.

> Be strong in the Lord and his mighty power. Put on the full armor of God so that you can take your stand against the devil's schemes. For our struggle is not against flesh and blood, but against the rulers, against the authorities, against the powers of this dark world and the spiritual forces of evil in the heavenly realms. (Ephesians 6:10–13)

We are getting ready for war with Satan and his minions, and it can happen at any time. So we need to be prepared. We are also encouraged to "stand your ground, and … stand firm" (Ephesians 6:13–14). This requires

preparation, commitment, bravery, and confidence. We are constantly fighting against these forces and evil powers to some degree. Only by knowing how to fight them, using God's own words, will we keep ourselves from some further degree of injury.

You are to be commended if you've gotten this far in the booklet. We are dealing with profound spiritual issues. The battle referred to in these verses is called spiritual warfare. Most of what this booklet involves relates to spiritual warfare. I have waited until now to introduce this term. This is a topic that many mainline Christian churches avoid. Very few of them study, preach, or even talk about it. Most of them are afraid of it, so they ignore it. They prefer ignorance over knowledge. They choose to believe that "ignorance is bliss" rather than "knowledge is power."

You have now been exposed to much more than many other Christians. Congratulations on your bravery. Carry on until it is finished, and then share it with others!

PUTTING ON EACH PIECE—
DEFENSIVE WEAPONS

PUTTING ON THE armor of God is the ultimate tool for disrupting Satan's evil agenda. Second Corinthians tells us that each piece of the armor of God possesses divine power.

> The weapons we fight with are not the weapons of the world. On the contrary, they have the divine power to demolish strongholds. (2 Corinthians 10:4)

Since the armor pieces are not tangible, putting them on our bodies involves some imagination to go along with our faith. As you read this section on the armor of God, visualize all the pieces laid out on the ground before you. Treat them as if you are going to put them on your body. Speak of each piece separately, and remind yourself of its significance as you put it on. When they are all in place, do not consider them separate pieces of physical equipment Satan can feel when struck in battle. It will sting much more when God wields His weapons' power. Instead, think of them as the many ways God helps us as if we are covered in Himself and His overwhelming power. The almighty God surrounds us for our protection as we fight our darkness.

Here is your first piece and an explanation of its significance.

> Stand firm then, with the belt of truth buckled around your waist. (Ephesians 6:14)

Only when the belt is buckled can the soldier's flowing clothes be tucked away so they don't get in the way of fighting. He must have maximum maneuverability as he moves forward to fight his enemy. Only now can his weapons be securely attached to his belt, allowing easy access when needed. He must stand firmly in position to be prepared to move forward toward the enemy or keep from moving backward as the enemy attempts to overrun him.

Whenever soldiers go to war, they must be confident about whom and what they are fighting. Their willingness and enthusiasm will wane unless they are fighting for truth. When we fight evil, we are also willing to fight for the truth and the protections it provides. The truth, of course, is Jesus, and our enemy is Satan and his emissaries.

The next piece provides additional protection for the chest:

> … with the breastplate of righteousness in place. (Ephesians 6:14)

The breastplate covers the primary organs of life (heart, lungs, and yes, even a separate "little brain"). Without it, any physical or spiritual blows to the chest area could diminish or destroy our blood, oxygen, and cognitive skills and even impact learning, memory, and spirituality.

Because the Bible tells us that we are considered righteous in Christ, we know that our vital organs for a righteous spiritual life are protected from evil. As Christian soldiers, this gives us great confidence in being protected in spiritual battles.

We can also have peace.

> ….and with your feet fitted with the readiness from the gospel of peace. (Ephesians 6:15)

The need for proper footwear for any soldier is, without doubt, a necessity. He is inadequate if he cannot quickly move from place to place. He must have a peace of mind that cannot deter Him from his purpose. We face the same issues when we fight a spiritual enemy who will do anything to disrupt our pathway to victory. Satan will litter our path with symbolic rocks, nails, sand spurs, explosives, holes, and tacks. But Jesus gives us peace against these spiritual deterrents. As we walk to and during the battle, God gives us peace because our path is clear and made clear to us.

The shield comes next.

> In addition to all this, take up the shield of faith, with which you can extinguish all the flaming arrows of the evil one. (Ephesians 6:16)

Soldiers have metal shields that can protect them from incoming artillery over long distances. When rows and rows of soldiers stand side by side, they raise their shields and lower their heads. Hopefully, this provides impenetrable solid protection against incoming arrows, spears, and javelins. They put their faith in this armor when they and their trusted compatriots hold up their collective security.

We, as believers, are protected similarly. We hold our faith in Jesus through our prayers and praise. We are sure of what we hope for and certain of what we cannot see. And although we are on a spiritual battlefield, we are likewise protected from our enemy and his evil lies. Because of our faith, we are assured of protection from Satan and his demons because Jesus is right there with us.

> "Where two or three are gathered in my name, there I am with them." (Matthew 18:20).

Next, we cover our heads with a spiritual helmet.

> Take the helmet of salvation. (Ephesians 6:17)

A soldier seldom survives when a flying weapon of death strikes his brain. He protects as much as he can with a protective helmet that hopefully cannot be penetrated.

When I put on the helmet of salvation, I do not primarily refer to being saved from the penalty of sin. That gift is guaranteed to us only when we accept Jesus as our Lord and Savior, which is available because Jesus died for us on the cross. This gift lasts for eternity.

As Christians, we are now looking for additional protection. We can now be blessed with a saving knowledge that emanates from the first. This is the one I believe is being referred to in Ephesians 6:17. It is salvation from the power of sin. When we walk closely with God, Satan no longer has the same power to influence us in our daily lives.

When we die and enter heaven, since Satan will not be present and thus no longer around to tempt us into sin—we are finally saved from the presence of sin. This will last throughout eternity.

PUTTING ON EACH PIECE— THE ONLY OFFENSIVE WEAPON!

NOW, WE GO on the offensive against evil. We can only do this with the sword.

> Take ... the sword of the Spirit, which is the word of God. (Ephesians 6:17)

The previous pieces of armor are the defensive weapons that God provides. Although we can be seriously injured, they do protect us from death and lethal injury. However, they alone will not defeat Satan because only offensive weapons can fight back and win. The final weapon is a small double-edged sword called a Makira. Its short length and precision sharpness allow the mobility in close combat to find a vulnerable place on the enemy's body to insert the fatal blow.

> For the word of God is alive and active. Sharper than any double-edged sword, it penetrates even to dividing soul and spirit, joints and marrow; it judges the thoughts and attitudes of the heart. (Hebrews 4:12)

Only a sword can be an offensive weapon against our enemies. Only the sword can kill the enemy. This allows us to fight to win, not just to draw.

When we begin the day in prayer (or at any time during the day), God covers us with His armor—God Himself. We become able to stand firm while we face our spiritual struggles. We are prepared for that day. We are protected by God's salvation, truth, faith, peace, shield, sword, and breastplate.

Repeating these verses on spiritual warfare can provide amazing strength and confidence of success any time we sense Satan facing off against us in a spiritual war. I try to pray these verses first thing each morning. I prefer to have this protection before Satan attacks rather than respond to his subsequent attack later in the day.

The apostle Paul instructs us:

> Pray in the Spirit on all occasions with all kinds of prayers and requests. With this in mind, be alert and always pray for all the Lord's people. (Ephesians 6:18)

ONE-TWO PUNCH

SATAN IS A brilliant opponent who knows and understands much about us and then uses it against us. How can we protect ourselves from Satan's getting to know us so well that he can start using what he has learned against us?

Although most denominations teach that neither demons nor Satan can physically enter our Christian bodies, they can still use accusations, deceptions, lies, and temptations as tools to ruin our lives. The evil one introduces evil ideas into our minds that can wreck our lives without being recognized and rejected. The ideas include evil thoughts, false stories, fears, unbelief, lies, deceit, other gods, unholy spirits, false teachings, godless worldviews, materialism, discord, and pornography, to name a few. It is essential always to be on guard and ready to respond.

There is an excellent one-two biblical punch when you sense demons trying to wreak havoc in your mind. The following verse should be said in an authoritative tone:

> We take captive every thought to make it obedient to Christ. (2 Corinthians 10:5)

Although this verse only specifies "thoughts" as being taken captive, I believe the verse extends way beyond just "thoughts." Depending on what

Satan has said (or introduced) into my mind, I also like to substitute other words for "thoughts"—such as fears, stress, false gods, and failure.

Philippians 4:8 can be used as a follow-up verse and is essential to keep a demon from returning with even more evil support. Make sure your mind is full of godly thoughts from Christ's mind, which will repel demons when they return, no matter their number. And believe me, they will return!

> My friends, fill your minds with those things that are good and that deserve praise: things that are true, noble, right, pure, lovely, and honorable. (Philippians 4:8 GNT)

When Satan and his demons are taken captive at the entrance to our minds, they will flee to another open space. They will regroup and return with a much stronger army of demons. If the mind is not filled with authentic, noble, proper, pure, lovely, and honorable things, our mind will soon be attacked again.

And you do not want to face demons a second time!

DEALING WITH PRIDE

BEFORE WE FINISH, I'd like to warn you about an emotion that can creep up and disrupt your progress. While fighting depression, I'd sometimes advance very quickly and often become delighted, joyful, and satisfied with myself. I found out later that research shows we can become self-centered, self-involved, and even narcissistic if our emotions get too far out of control. But I never thought I was out of control; I just thought I was being confident about my well-earned success.

The biblical word for this emotion is pride; I was its poster boy. And I still suffer from it. I was reminded of this while writing this section of the booklet. I remember how proud I was of myself when I first memorized so many verses years ago. I bragged about my success. I used them as often as I could. And I encouraged others to do the same. Today, I wonder how much that pride might have damaged my full recovery and subsequent testimony.

Recently, I returned to relearning all the verses I had stored away on cards. They came to mind reasonably well for a week or so, and guess what? I was puffing up with pride. Then, when I started reviewing them one morning later, I could not remember them. I had experienced déjà vu.

I said to myself: "What's happening? I've been doing great!" Then this thought immediately entered my mind. "Bill, it's your pride. That's the problem." Many of us justify pride as beneficial in achieving goals and

success. This may have some validity, but pride primarily involves ego and arrogance, which God abhors.

> Pride goes before destruction, a haughty spirit before a fall. (Proverbs 16:18)

> When pride comes, then comes disgrace, but with humility comes wisdom. (Proverbs 11:2)

Pride is not only treated as a sin in the Bible but also referred to as one of the seven deadly sins, in addition to lust, gluttony, greed, laziness, wrath, and envy. So if pride is an emotion and considered a sin, does that mean all the negative emotions are also sins? The ones that you and I share?

I believe they are not necessarily sins by themselves. But when emotions get out of hand and result in actions that violate God's intentions, they most likely qualify as sins at that point. I base my opinion on the fact that when the Bible tells us about Jesus's experience in the garden of Gethsemane, it says that Jesus was sorrowful and deeply distressed, "even unto death." But as you know, Jesus never sinned. So his emotions could not have been sinful because they never got out of hand and never violated God's intentions.

A FINAL PRAYER FOR YOU AND ME

Thank You, Lord, for providing us with Your inspiration and Word. It is beyond understanding how the Bible has the perfect answer for every problem we face in life. Undoubtedly, if Your Word is embraced, followed, and shared with others, we will be blessed with Your wisdom in adjusting our emotions to bring needed change to our lives. Thank You for Your words, which stabilize our emotions and prevent them from being used improperly and hurtfully. Thank You for providing us with practical and powerful tools for dealing with evil and sin. Please help us have the courage, strength, and conviction to use what we have learned from reading this booklet to bring needed change to our lives. I pray this in Jesus's name, Amen!

OTHER TITLES BY CASTLE QUAY BOOKS

OTHER TITLES BY CASTLE QUAY BOOKS

OTHER TITLES BY CASTLE QUAY BOOKS

www.ingramcontent.com/pod-product-compliance
Lightning Source LLC
LaVergne TN
LVHW010319070426
835512LV00028B/3494

SOLE FOOD

BY JEMAYNE L. KING

ACKNOWLEDGMENTS

Mrs. and Mr. Lois and Willie King Jr.
Virginia State University

DEDICATED TO

The Culture

CONTENTS

RETRO RELEASES

Much Ado about Retros	1
Retroed	3
A Lesson Learned	4
Black Kicks in the Summer	5
Bridging the Gap	6
Evolution	7
Hope Floats	8
Lab Partners	9
Slippery Slope Fallacy	10
Sole Mate	11
Stowe Away	12
The Thomas Sutpen Dream	13
The Ewing Athletics 33 Hi	14

LIFESTYLE RELEASES

The Freezer	17
Walk-in Closet: 2008	19
You Get Paid for This?	20
Terrible Swift Sword	21
Ten Kick Commandments	22
SIT LUX	23
Ode to a Hypebeast	24
First Date	25
Made Ya Look!	26
Kick	27
Jump to the Rhythm	28

Felon Shoes	29
Dia de los Muertos	30
Booster Pack	31
Boom B.A.P.	32
Believing the Hype	33
Antiques Made Daily	34
This or That	35
By No Means	36
I Need Answers!	37
Neck Breaking 101	38

B A C K T O S C H O O L R E L E A S E S

Chase	39
Changing the World	42
23223	43
The UPS Truck	44
Wet Behind the Ears	45
Table Talk	46
The Code	47
Savory Yellow Miss	48
Product Knowledge	49
Please Recycle	50
Mr. Dingy White Tee	51
Living with Regrets	52
Fast Asleep	53
Dario (Snoop)	54

L I M I T E D R E L E A S E S

Beasts from the East	57
Faceted Jewel	59
Corna' Sto'	60
Black Spending Power	61
A Rose by Any Other Name	62

Sneakerdoodle Recipe	63
Shawn Hobbs	64

Hyperstrike Releases

Like Capitalism	67
Boom B.A.P. VI	81
Midsolesdontcrack.com	82
Collaboration	83
Dating Sneakerheads	84
You Fit the Description	85

Fifteenth Anniversary Poems

Ailuropoda Melanoleuca	86
Karl's Jr.	87
Karl's Jr.'s Expansion Pack	88
The Mongol Empire	89
11368	90
Three the Yard Way	91
Who Cares?	92
The Question Remains	93
Who Sold You That Jank?	94
"Well, That's Just Too Damn Bad!"	95
If She Loves Leopard Print	96
Chicos, Adios!	97
If It Ain't Broke …	98
Little Big Brother	99
What, to the Unemployed, Is a Labor Day Sale?	100

Sole Food Celebrating Fifteen Years

So many things have happened within sneaker culture since *Sole Food: Digestible Sneaker Culture* published fifteen years ago. Baggy clothes are slowly—but surely—making a return. Sock shoes morphed back into bulky shoes and sneakers with a "dad shoe" aesthetic. Jordan Brand is replicating its traditional business model; ride the donkey until it collapses. Fifteen years ago, the trend was their Air Jordan retros. Currently, it is the Air Jordan I silhouette—in each of its variations. Though they are beginning to down trend, everyone from grandmothers to mall dwellers can be spotted in them. This is also true for sneakers with a similar cupsole. For example, Travis Scott brought attention to the Nike Dunk SB in 2020. Since, general release Nike Dunk sales have skyrocketed. Notoriously, the Nike Dunk "Panda" is sneaker culture's answer to the 1970s' Pet Rock fad. Adidas continued to pick up marketing shares; this was largely due to its partnership with (Kan)Ye West. However, the company experienced significant losses due to West's antisemitic statements and similar off-color remarks.

Regarding losses, Adidas also parted ways with Beyonce's Ivy Park due to low sales. Nike sought litigation against upstart "companies" infringing on their intellectual properties. This is significantly due to Mom-and-Pop startups gaining the modes of production. Yet, after obtaining manufacturing, they elect to

illegally re-create Nike retros. Since retro is still en vouge, smaller (legitimate) brands continue to profit. Revived retro brands include—but are not limited to—Jaclar, Spot-Bilt, and Avia's basketball division. Thus, sneaker culture is not different from fashion's cyclical nature. Sneakers that fall out of favor eventually retro to fanfare.

Considering collaborations, sneaker culture tastemakers, designers, and entertainers continued to thrive. Consequently, Albert Lebron procured a second Ewing Squad collaboration with Ewing Athletic. Virgil Abloh's Off-White brand elevated Nike's offerings to near luxury brand credibility. During the last fifteen years, Travis Scott's various Nike/Air Jordan offerings have become so popular, they are routinely illegally manufactured by unauthorized factories. So much so that some wearers are more familiar with Scott's sneakers than they are with his music. Five years later, Sean Wotherspoon still maintains a space within the sneaker industry. His connection with Nike gave birth to partnership with Adidas and industry outside of sneaker culture. These ventures include—but are not limited to—partnerships with Louis Vuitton, Guess, and Porsche. This is significant; sneaker culture continues to grow from subculture to popular culture. Gone are the days when athletes influenced sneaker sales. Influencers, entertainers, and internet phenoms still have more influence than athletes since *Sole Food: Digestible Sneaker Culture*'s last incarnation. Still found at the center of dissertations, and on the feet of college presidents and corporate executives, fifteen years later the culture lives and is thriving.

Foreword

By now I'm sure many of us have heard the quote, "The creative adult is the child who survived." While its origin and author are somewhat unknown, the sentiment, from my perspective at least, goes deeper than the many memes and crafty Etsy-style wall pieces imply.

Writing this at age thirty-two, I have approximately twenty-five years worth of authentic subscription to sneaker culture, with memories as early as seven or eight years old. As a practitioner, throughout those years I have had the privilege to leverage sneakers as a gateway to friendships, business, career development, community impact, and many more opportunities I'd be proud to list. I've helped pattern boutique retailers into community centers, helped connect resources and civic engagement to the very community I grew up in. Several of those opportunities came at the hands of the author of this very text, including the opportunity for you to read this today.

Many people never get the opportunity to see the interests and subcultures of their youth grow into a massive, sustainable industry. Many people never get the chance to participate in shaping portions of that industry or have the incredible experience of creating opportunities to bring it to their peers. I can't relate—sneakers are now a global phenomenon, and the culture has shifted as the industry has grown. New generations enter and new paths to subscription are created—both authentic and inauthentic alike. However, one fact

remains true; no matter what is created, we stand on the shoulders of the people who came before us. We stand on the shoulders of people like Dr. Jemayne Lavar King.

I met Dr. King as a bright-eyed and energetic freshman attending Winston-Salem State University, eager to impact the cultures that helped raise me. We were connected by one of my best friends, Thaddeus Williams, a student of Dr. King's at Johnson C. Smith University—shoutout Culture Set! My experience started how many of yours are right now—reading Dr. King's books, buying his merchandise, and trying to figure out, "How is this even possible? You've written and contributed to multiple books about sneakers and sneaker culture? You're developing a course? Wait ... you're starting your dissertation ... and it's about sneakers?" From the state the culture was in back in the mid 2000s and 2010s, it all seemed ... impossible to my young brain. I was inspired and my world was expanding. The culture was expanding. I could have never imagined how many opportunities would come at the inception of this relationship. I also could never imagine the number of stories I would hear that were just as similar to mine, with Doc as the common denominator. Expanding the worlds of the next generation and helping them connect the dots. Making pathways for them to become creative adults, helping more children survive.

I've called Jemayne "Doc" since I heard about his PhD candidacy in the latter part of my undergraduate matriculation. The sheer act of pursuing the culture that we loved, at the highest levels of academia, was enough for me to say "It is so," far before he earned the regalia. The pursuit for me is just as admirable as the title.

Often when we see the cultures we create intersect with institutions at this level, it has been stripped from our hands, reduced

to frameworks, and infused with psychology that does not reflect the experiences of the people at its inception. Oftentimes, it's weak and lacks depth or impact. Our cultures often make it to these spaces without being ushered in by someone who helped create them. Doc has climbed that mountain and planted the flag—it cannot be ignored.

As you embark on your journey through this text, I want to encourage you to read between the lines. If you sit with these writings and research what informs them, you will have a greater appreciation for the weight they truly hold. The people who see themselves represented and the people who have had their lives changed through this work. What you are about to experience in this text are the intimate writings of one of those surviving children. A creative adult who went on to become a pioneer, a game changer, a mentor, an innovator, a professor, and many other titles that deserve to be bestowed. With this edition, *Sole Food: Digestible Sneaker Culture* turns fifteen, but the impact of these words and the work of their author will live far beyond the years any of us will ever see.

Welcome and enjoy!
David J. Butler

RETRO RELEASES
MUCH ADO ABOUT RETROS

Depending on whom you ask, retro sneakers are either the degradation of a pristine culture or the celebration of it. For collectors, retro sneakers depreciate the value of original models and rare limited-edition releases. Sneaker purists who celebrate the elements of original designs become enraged when retros are released with modified features. Similar to the automotive industry (I will leave the 1967 versus 1995 versus 2018 Cobra Mustang debate to my car corollaries), sneaker culture has a community of enthusiasts who purchase sneakers because of nostalgia. For them, retros provide a connection to memories of peregrinations to the shopping mall, imbued with childhood folly and rudimentary lessons in economics.

Sneaker companies, however, recognize the earning potential in reintroducing discontinued models. Newer generations of consumers who have not been exposed to the retro models essentially fall in love for the first time. Sneaker companies then generate new revenue for old products. As a related consequence, companies are presented with a unique opportunity to capitalize on marketing and design mistakes in the original product and campaign.

Though seemingly vulturistic, there is a positive side to this type of marketing. Improved technological designs allow current athletes to wear older sneakers during active competition. Companies then release team color editions of the updated models for consumers, along with versions that are exclusive to professional athletes, many of whom also carry a fondness for the hallowed footwear of their high school days. This in turn creates a renewed hysteria for the sneaker seen kicking, sprinting, and jumping its way into world-champion status. Many consumers purchase goods based solely on celebrity connections; sneakerheads are certainly no different. Undoubtedly, the competition for the endorsement of each sport's top athletes is often comparably as fierce as the respective tournaments.

Much of the controversy surrounding retro sneakers stems from a creativity and design standpoint. So much revenue is being generated from retro releases that the design muse is not being stimulated. All of this raises a new question: What will be the must-have retro sneaker of tomorrow?

Retroed

I was released in 1988 before you would be,
Twenty falls later, you would acquire me.
A change in time but my impact's the same,
You will spend your last dime to wear my surname.
Standing on line with hopes to be first,
At the very same time her water burst.
You've heard of my stories and seen a few pictures,
Today, your part-time earnings will make you the victor.
My color scheme is unique, strange to say the least,
You imagine matching wears with funds from next week.
Your new son has your eyes, your affection he'll seek,
But you'll only provide him a cycle that repeats.

A Lesson Learned
(FOR MY MOTHER)

If I buy you those, you're getting nothing else for Christmas.
I mean it, **NOTHING** else.
Now, how much are they?

BLACK KICKS IN THE SUMMER

Black kicks in the summer,
Nothing more, nothing less,
White kicks in the winter,
White kicks in the fall,
The black kicks are reserved
For those who can ball.

Bridging the Gap

The apple of my eye in 1993,
Pa Pa got them for you just last week.
Fifteen years later, they're finally mine.
You shoot ball in yours, you have a good time.
I look at them and think of that fabled timeout.
You seek some new pair for these have timed-out.
We're of different generations, different goals and ideas,
Yet we both know beauty, and that bridges the years.

Evolution
(For my father)

1995:
Tupac's music: You said you couldn't stand it.

2008:
Now your feet are Makaveli-branded.

Hope Floats

I started each and every year with a brand-new pair.
What if each shoebox had a book in there?
On the first day of school,
That would be my only care,
To flaunt my brand-new knowledge,
Like a pair of Nike Airs.

Lab Partners

I know she sees me.
Ain't easy being cheesy,
With kicks so greasy.

SLIPPERY SLOPE FALLACY

I've been waiting too long.
I can't anymore; chores for weeks, I'm callous and sore. Hand me down this, worn out that, I'll slide in his room, and put them all back. When Tasha sees me, no cliché to Fester; king on my throne, someone else can play jester. I opt to walk home, feeling good about my gesture. Then I spied brother's car, the first break of semester.

Sole Mate

I was only twelve when I saw you for the first time; I longed
to be with you but the opportunity passed. I saw you in
the company of others, their intentions were pretentious,
you asked no questions, you simply offered support.
I remembered when you left only to periodically return.
I yearned to see your true colors; but I became pre-
occupied with life. I moved on to new tasks and
challenges; you found a new generation of
admirers to lose themselves in your
splendor. I became upset with
your schemes, upset with
your change. Even
in my mind's
eye you'll
never be
the
s
a
m
e.

Stowe Away

I have no idea
From whence this passion came,
Perhaps it grew like Topsy,
A collection as little as Eva,
Now meaner than Legree,
As I travel down the river,
My ambition grows bigger,
Abolishing all thoughts of failure,
What a thing to be a sneakerhead.

THE THOMAS SUTPEN DREAM

Eleven years ago, not a penny to my name,
With each shoebox,
A brick,
For my personal Hall of Fame.
Lightly since August,
Does the brick collection grow,
One hundred bricks here,
Twelve hundred more to go.

The Ewing Athletics 33 Hi

It seems as if I'm always asked, "What is your favorite sneaker of all time?" My answer usually is recited before the inquirer speaks their last syllable. For me, there's no doubt that it's the Ewing Athletics 33 Hi.

Patrick Ewing was the first lottery pick in NBA draft history. Coming out of Georgetown University in 1985, Ewing was selected by the New York Knickerbockers; he was tabbed as the best prospect in that year's draft. I identified with Ewing because he was a large, hard-working gentleman who tended to perspire.

Initially, Ewing signed an endorsement deal with Adidas. Through them, he acquired a line that included clothing and shoes. Ewing later left Adidas to start his own brand. He created Ewing Athletics; shortly thereafter, the brand released the 33 Hi. The shoe was a true high-top that offered optimal support. The company went on to produce Ewing sneakers every year for a few years; but the apple of my eye was the second Ewing. It was released during the 1989-90 season; I could not wait to get a pair. That season, the Knicks faced the Boston Celtics in the first round of the NBA playoffs. In those days, the first round was a best of five playoff, meaning the first team to three wins would win the series and move into the second round of the playoffs. Boston finished the regular season with a 52-30 record; the Knicks finished with a 45-37 record. As a result, Boston secured home court advantage in the series.

Things seemed bleak for the Knicks. New York had not won a game on Boston's court since 1984. The Knicks lost the first two games to Boston. However, things improved as the Knicks

went on to win the next three games in a row—and the series. I remember Stu Jackson yelling at Pat to shoot a three-point shot from the corner in game five—and I remember the shoes on his feet. They were white, royal blue, and orange. I was in love with a shoe for the first time.

My mother told me I could get a pair on one condition: I would have to wait a week to purchase them. I took my allowance and put them on layaway. There would be a grueling seven days between my Ewings and me.

The very next week I ventured to the store to buy my shoes and the manager informed me that the store's inventory had been stolen, including my white-and-red Ewings! Fortunately, this story has a happy ending. They gave me a full refund; but I would not procure my first pair of Ewing Athletics 33 Hi until September 2012, when the brand resurrected. I've been in Ewing Athletics Heaven since.

LIFESTYLE RELEASES
THE FREEZER

I grew up in a household that featured a freezer full of food. No, not that little box on top of the fridge, but a big, long one that had its own special area in our house. My grandmother had two of them in her home. It seemed that just about every household I visited had at least one freezer. Their purpose? To preserve food for later consumption—much later consumption. Ironically, there is a sneaker culture parallel that many miss.

I vividly remember asking for a pair of Reebok Omni Zone Pumps for Christmas during my seventh-grade year of middle school. After much pleading, my parents made sure I got them. For the moment, it seemed the world and everything in it was perfect. Needless to say, I was appreciative for my gift. I was so appreciative that between January and April, I wore the shoes only three times. This was the first time I treated a pair of sneakers this way. I recognized that $100 was a lot of money for pair of shoes. Also, as a child, I wanted my shoes to never look worn down. I took pride that this white, purple, and black pair looked fresh months later. During those days, this was unheard of. Shoes were purchased to be worn and eventually replaced, and this pair would eventually be replaced. However,

I wanted to bypass the "worn" part of the narrative. Nevertheless, some way or another, the man-made upper developed a split in the material. When my mother discovered this imperfection, she took my holy grails back to Belk-Leggett. The salesperson had no problem issuing a refund. The outsole had no traces of dirt because they had never touched earth! I made it my business to only walk on concrete the three times I wore them.

My mother gave me the money to purchase a new pair, and our next stop was a mom-and-pop store called Branch's. With the Reebok Omni Zone Pump money, I was able to buy two pairs at this store. I walked away with a white-and-royal-blue pair of Converse ERX 150 kicks and a pair of multi-colored Air Ultra Force Hi Nikes. I could have rotated these pairs every other day and fully enjoyed my investment; but they surely would have been dogged by the last day of school. It was during this time I experienced an epiphany that changed my way of thinking forever. I wore each pair once, then banished them to the back of my closet, only to return the following September. Basically, my closet became a freezer. The next school year, I knew I would have at least three new pairs to start school.

After reading Bobbito Garcia's masterpiece, *Where'd You Get Those?*, I was jettisoned back to my childhood. He talked about the patience it took to put a pair on ice for wearing later. Today, I am proud to say that I have more than a few pairs on ice. I need a bigger freezer.

Walk-in Closet: 2008

I've got a pair that survived Hurricane Floyd,
I've got a pair I bought because I was annoyed,
I've got a pair I've owned since sixteen,
I've got a pair that's cool grey with a sole that's lime green,
I've got a pair in the colors of my alma mater,
I've got a pair I cherish, presented by my father,
I've got a pair I purchased by mail,
I've got a pair I procured on sale,
I've got a pair that would have you question your mother,
I've got a pair called "self;" there isn't another,
I've got a pink pair I dedicated to early detection,
I've got a **BLACK** pair I'll wear during November's election.

You Get Paid for This?

For holding up the wall …
For improperly greeting patrons …
For stealing products from the stockroom …
For running credit card scams …
For eating on the sales floor …
For texting while talking to me …
For taking two-hour lunch breaks …
For leaving work before your shift ends …
For selling products on eBay before their release date …
For talking on the phone during your shift …
For not looking for my size,
then lying to me about not having it in store …
For being a fountain of misinformation …

TERRIBLE SWIFT SWORD
(THE FIRST ROUND DRAFT BOARD)

1. Neat-Lee Pressed Suitt
2. Trey Quarter Dress Boots
3. Kosher Friendly Agents
4. Deep Family Roots
5. Greenroom Chocked Full
6. Empties Byda Moment
7. Today S. Yourday
8. Yore Special Moment
9. Cam Rah Snapshot
10. Mr. Paparazzi
11. Others Van Nash
12. Wonder Y. Notme
13. A. Promised Shoedeal
14. Gore-May Prepared Meals
15. Goda Wayofthe Dodo
16. A. Frozen Barron Field
17.
18.
19.
20.

THE TEN KICK COMMANDMENTS

1. Thou shalt have a variety of kicks.
2. Thou shalt not make unto thee any hypebeasts.
3. Thou shalt not take financial obligations in vain.
4. Thou shalt buy two pairs and place one pair on ice.
5. Honor thy mother and father.
6. Thou shalt not kill for kicks.
7. Thou shalt be original.
8. Thou shalt not steal kicks.
9. Thou shalt not wear fake kicks.
10. Thou shalt not covet kicks.

SIT LUX

The utility company just cut our power,
But my shirt and my kicks match; I'm the man of the hour!

ODE TO A HYPEBEAST

I'd tell you to get a life; but you'd probably find one online.
Someone mentioned my collection, and you spun like
Dwight Feeny.
Then you asked your classmate, "What is a Conbini?"

First Date

Tonight is the night,
It feels so right,
For she is the type,
I've been seeking since birth.
I may or I might,
Lace up tonight,
These lava-and-white,
And yes, they've never touched earth.
I've been given the chance,
Perhaps a kiss or a dance,
Genteel touch or a glance,
My heart has new girth.
All this week I've been coached,
On my initial approach,
Compliments on her broach,
Which glass to raise for the toast,
This date is my first.

MADE YA LOOK!

Did I shock you? Are you surprised?
My feet feel the burning sensation
Of your greedy eyes.
I make this look so easy,
'Tis really not that hard.
Besides,
You're the one with the fancy job.
You're already asking questions,
I'm not naming names.
You'd like to be a pawn
On my shoe chessboard.
I'm a zoom to the left,
I leave vapor trails of freshness
With every step.

Kick

I wake early for a big bowl of Kix.
Then I'm off to the mall, to cop some new kicks.
To my surprise, I see a girl with whom I used to kick it.
She tells me I was a hard habit to kick.
She's living with a guy, she's really trying to kick him out,
for her face he likes to punch and kick.
She jokes about making him a large pot of grits.
I say, "Oh, now you're on an Al Green Kick."
She replies, "No, I'm on a new life kick."
Just across the street, a stray dog is kicked
by a kid, he's rocking the kicks I wanna pick up.
I yell to the child, "Son, you need to kick!"
He then points to a pile of rocks for me to kick.
My ex-friend reaches in her bag,
In her hand, a 36 with a powerful kick.
I ask, "Whoa! Whose ass you tryna kick?"
Then she turned it on herself, the trigger went click.

Jump to the Rhythm

The other day, I saw a newborn draped in Jumpman's apparel,
All this before he'd see the beautiful flight of a sparrow,
Before seeing the summer's sun set at dusk,
Before spilling juice on the counter,
And hearing mother fuss,
Before becoming
An excited young tike,
Before placing ball cards
In the spokes of a bike,
Before developing character,
Before accomplishing goals,
I saw him modeling fashions,
Of designer street clothes.

Felon Shoes

I sit in this window daily,
It's me, Miss Bailey,
I overlook my city, my people and their babies,
I've seen a lot over time,
A whole lot of crime,
If those boys cross this street one more damn time!
They should be in school,
A pack of young fools,
Runnin' round town,
"Wit' no strings in
'Dem shoes."

DIA DE LOS MUERTOS

C.E.O. by thirty-three,
Vacation trips to Belize,
Conference calls from the Lear,
Admiration from every peer,
The number after the dot did change,
Everything else remained the same,
He never forgot the way to Sal's
Cheese pizza slices with all his pals,
The life he lived: hard but fair,
He did it his way amongst the stares,
It fueled his ambition, it paid his fare,
He would always be able to afford a pair.

Booster Pack

Jobs won't pay us,
Girls try to play us,
So, we steal shit,
Like José Reyes.
We're just tryin' to come up,
So, watch us run up,
Dem shoes worth yo life?
Go 'head and give 'em up.
Matter fact, run the jewels,
Dat chain is so cool,
You out here flossin',
Like a damn fool.
Hey, it's what we do for pay,
Every single day,
Thanks for your stuff,
Now have a nice day.

Boom B.A.P.

New outfit and nails,
Toes done too,
Phone calls placed to your homegirl crew.
A hunting you will go,
Off in the club,
Searching for that love, but only findin' thugs.
The clock says one,
The party has just begun,
You're still having fun, hun, but what about your son?
He's at home with his grams,
Empty cans of Spam,
You promised him new Forces, but now you're off with this man.
You peeped him in the street,
You met him in the sheets,
You don't return home 'til Wednesday of next week.
This is not the first time,
In your mother's house lying,
Your son is looking for his kicks,
Ones he'll never find.

BELIEVING THE HYPE

That kick was ugly until I saw it on the foot of my
favorite celebrity,
So, when I purchase six pair, don't get mad at me.

Antiques Made Daily

Living in your high school days,
This is not '98.
GED aspirations,
For your Friday-night date.
He left his wallet at home,
You gladly pay.
As it beats being home,
In your mom's way.
The world has him down,
You lend an ear.
You even supply funds,
For a pair of kicks and some beer.
Looking for stability
In a black coal mine,
Instead, finding reality
Of a Black concubine.

This or That

A brand-new pair
Or
A month's bus fare

Stuntin' over these crows
Or
Buying your children's school clothes

Stopping the shallow ones from dissin'
Or
Saving for college tuition

A vintage pair of Brooks
Or
Reading a book

Some new Pro Models
Or
Becoming a positive role model

Which will it be?

By No Means

She's like a goldfish,
If it's provided,
She will not stop.
You bought this,
You bought that,
A new purse,
A new hat,
A new whip,
with floor mats.
Hey,
You even let
Her get cheese
On that.
However,
The day you buy her shoes,
Your ass will sing the blues.

I Need Answers!

How can the poor afford $300 sneakers?
How can corporate America continue to market to them?

Neck Breaking 101

There is nothing more satisfying than capturing the attention of others, especially through the vehicle of footwear. The gratifying sensation of feeling sets of eyes locked upon one's footwork does wonders for individuals looking for attention—this, coupled with the smell of victory, knowing that the onlookers have no earthly idea how or where these weapons of mass destruction were found.

One of the tactics that made General "Stormin" H. Norman Schwarzkopf Jr. a successful military mind was the element of surprise. He simply did things the enemy did not expect. In the "kick" game, it often appears that everyone wears the same thing. Popular culture dictates what is fashionable in footwear, which becomes status quo. After awhile, one's identity within the culture becomes lost. Though risky, going against the grain could procure huge rewards.

Wearing a sneaker that is discontinued is, and will be, the most effective way to proverbially break someone's neck. "Neck breaking" or "snapping" is the effect procured when one turns too quickly while trying to catch a glimpse of the fancy pair of kicks someone else is wearing. Most people have a short memory when it comes to sneaker releases. If a fresh pair of sneakers from six months ago gets attention, imagine what a pair from three years ago could do. Other times, just wearing a shoe that everyone else forgot, or failed to recognize gets positive attention. However, neck breaking is not an exact science. Going too far against the grain could leave one out in the cold. The true art of neck breaking must be studied, cultivated, and nurtured over an extended period of time.

BACK TO SCHOOL RELEASES
CHASE

My first job out of graduate school was an assignment as a seventh-grade English teacher within Henrico County Public Schools in Richmond, Virginia. After serving for one year and experiencing numerous bumps and bruises in my at-risk school, I decided that my second year would have to go a lot smoother if I were to last in the business. At the outset of that second year, an e-mail was sent to all faculty members stating that Fridays would be designated as "jean days" to boost faculty production and morale. If nothing else, I knew I would be "freshly dipped" on Fridays. I looked forward to Fridays that year in the same manner a young child looks forward to the first snow day. Not only was I becoming a solid teacher after learning from my first-year experience, but I now had something to keep me motivated. I could save an outfit in my professional clothes collection and be at my most comfortable state on the most important work day of the week … *Friday!*

At my campus-styled school, teachers were charged with the task of standing at the doors of their classrooms, in an effort to move students along on the walkway. I did not look forward to this task,

as I would always have a plethora of students hanging around my door. Don't get me wrong; I loved the fact that students identified with me and my teaching style. What bothered me was the fact that the seventh-grade administrator would routinely walk by and toss worried looks my way that irked me. To him, it looked like I encouraged the loafing. I developed a system where I would have a three-minute conversation with each visitor then ask, "Hey, where's your homeroom?" Students would get the picture and reluctantly leave.

On Fridays, I swear that traffic doubled! One student named Ed, an eighth grader, routinely came to my room to see what sneakers I was wearing. At the time, I couldn't understand what the big deal was. I did notice I had a cult following of student fans, and I had developed supreme classroom management. Yeah, I'd learned from the first year; but I also knew my fly kicks gave me an edge in receiving respect from students school-wide. They related to me.

After a couple of months, one morning my seventh-grade administrator approached me and said, "Tomorrow Chase is being switched to your English class, and he's pretty excited about the move too!" The only reason I knew who he was talking about was because I'd witnessed a teacher having a nervous breakdown. After she calmed down, I asked her what was bothering her. She immediately started to cry again and screamed, *"Chase!"*

It didn't bother me that I was receiving a new student, even if it was Chase. I was already teaching a room chock-full of students, and one more didn't matter. When he arrived, I remembered I'd met Chase before. I would encounter him on the sidewalk during my planning period. One day during the previous year, his sixth-grade year, I approached him to give him props on a fresh pair of

Huarache 2K4s. I asked him, "Son, who has you so fresh today?" He replied, "My mom."

When Chase arrived, he pulled me to the side. He said, "Mr. King, could you not call on me to read aloud? I don't read that well." I told Chase I would never embarrass him and that we would work on his reading privately. For the duration of the school year, Chase never once disrupted my classroom environment. Later that year, he started to volunteer to read aloud on his own. I can honestly say, I've never had a favorite student, but I'll never forget Chase. Perhaps one day soon, I'll see him continue his education by walking into my college classroom. Then we could trade kick stories on an adult level.

Changing the World
For Starbury

Fifteen years ago, oh how we wished,
Hakeem and Patrick tried but they both missed,
Shaq followed suit with more good news,
The consumer then yelled, **"BIG MEN CAN'T SELL SHOES!"**
The mothers still slaved, new hustles for new dollars,
"My baby needs shoes before school starts tomorrow."
Who sets the precedent? Who changes the rules?
$15 for shoes? I can afford maybe two.
Now that I think of it, I can maybe afford eight,
Lookin' good, feelin' good, and my bills are not late!

23223

I have my own lingo,
Cadillacs are my thing,
I sport those sneakers with the straps,
I double up the strings,
Dreams of being paid,
My sight blocked by EK shades,
Family values still present,
Summer cookouts with lemonade,
My lifestyle is too good,
The odds I will beat,
They'll just push me through life,
Like that middle school did down the street,
Either you're in or you're out,
I plan to be in,
Because of a website with release dates,
I share with all my friends.

The UPS Truck

I've waited two weeks,
Aww, shucks,
Just around the corner,
Is the UPS truck.

Wet Behind the Ears

The ones you begged for
Are fourteen years older than you.
Yet you know everything
And nothing, truth be told.
You read NO literature,
They don't make those in green.
Bootleg guy sees you coming
Then sells you a dream.
Yet, you're fresher than a newborn,
Your respect is drawn.
He sold you a size 10,
So, why do you have corns?
Yet, you're fresher
Than newly cut grass,
Strolling through the mall
While patrons laugh at your ass.

Table Talk

I'm paying for them.
Don't worry about a thing.
What a perfect fit.

THE CODE

The heat is so intense; it proves too much to bear.
This morning it seemed so simple, you laced them without a care.
Eighty-two steps to your locker, now multiplied by twenty-five.
There is no place to run, no place to hide.
The code has been broken thanks to a 30% off sale.
Your crime: **Sneaker Biting**
Your punishment: **High School Hell**

SAVORY YELLOW MISS

Every day it appears that you're headed for a
fashion shoot of some sort,
Last night I opted not to study for watching
you parade around the library.
Your wavy hair is synthetic and so are your mannerisms,
Yet, it appears that everything is in place.
You go where the money is, your mother taught you well,
Kitten heels to wedges, wedges to crisp sneakers,
Crisp sneakers to wedges, wedges to stilettos.
You've become quite dizzy, I think even you have lost count,
That last one had a crisp tee, kicks impeccably-laced,
Today, I'm getting the same pair in a different color.

Product Knowledge

Hi there, Mr. Trust Fund Baby. I hope your day has been fruitful. I have descended upon your establishment on this most joyous occasion to make a purchase, and I am lucky to have your expertise at my disposal. After a brief chat with you, I've discovered that not only do you not know the basic principles of customer service, you also have no knowledge of the products for sale. Yes, I know you are the black sheep of your family, and that you are only lashing out against your father. My question to you is … You know what? I'm sorry for wasting your time. Good day, sir.

Please Recycle

I hold the gift in my mouth
That's what I'm all about.
The badge on my face
Is where I get my clout.
There is no doubt
Once I hit your house,
You flip me open
And take 'dem thangs out.
A simple design scheme
Craved for by fiends.
I end up crushed
I no longer hold your dream.

Mr. Dingy White Tee

Mr. dingy white tee man,
Mr. whole check gone in one trip to the mall man,
Mr. I'm up early on Saturday too, man,
Mr. this pair of kicks validates me man,
Mr. concerned with the next man, man,
Mr. I support terrorism by purchasing counterfeit goods man,
Mr. hypebeast of the year man,
Mr. "Why won't that girl talk to me?" man,
Mr. monochrome Dickie shirt and short set,
looking like a damned fool man,
Mr. I front like I would, but I really wish I could man.

Living with Regrets

I simply placed a sign on my door stating:
'NO OFFICE HOURS TODAY'
Straight to the parking lot I made my way.
I-77 was clear, there was no traffic,
My car is the Mach 5 with a few less gadgets.
While I've acquired a hunger that must be fed,
My speedometer touches a line that is red.
My intrepid destination reached, but to my surprise,
"I am so sorry, sir; we don't have your size."

Fast Asleep

May, 1999
"Excuse me, are these real Saucony?"
"No sir, we keep the authentic $28.99 sneakers in a special bin in the back."

Dario (Snoop)

My parents' words were not enough to mentally prepare me for the things I'd see happen all around me once I matriculated to college. My parents provided me with a permanent foundation—advice that would eventually lead to graduation and beyond—that to this day, I've been able to build upon with bricks of solid judgment and mortar of morale. The surprise was that many of the individuals I would go on to meet in college, many of whom are now successful, did not have such a foundation. In other words, Johnny Culture-shock lived in my dorm and he made sure he introduced himself to me upon my arrival. His room was next door to Mr. Dusted-n-disgusted.

I was assigned a corner room in the dormitory. The corner rooms were larger than the others and came with *two* roommates. I met J-Roc first, and then later that evening, I had the pleasure of meeting Dario. Dario quickly explained that he was from Richmond, was entering his second year of college, and commonly went by the moniker "Snoop." I looked him up and down and thought to myself, "Dude looks nothing like a Charles Schulz character or Calvin Broadus." I later found out that Snoop—Dario—was also an avid rapper.

It took a few weeks to get adjusted to living with these guys; it seemed as if we had nothing in common except that we all breathed air. This proved difficult for me at times, as Snoop had a few extra-curricular activities that had me exploring other housing options. Snoop's freestyling at times left much to be desired. One day, I grew so tired of his rapping, I interrupted him with a freestyle of my own that must have lasted five minutes. I made sure to include

in the freestyle subtle hints that living with him was a joke, and that at the time, I thought he was a cro-magnon man personified.

All of this went over his head; he was shocked I could rap. He yelled, "Awwww, I didn't know you could flow, sha!" I told him I didn't consider myself a rapper, but growing up listening to so much of it made it an easy attempt. We found we had more than a few things in common. We both were sneaker aficionados and we both grew up embracing Hip Hop culture and professional wrestling. Snoop was the first person I talked to after discovering the Notorious B.I.G. had been murdered.

One day, Snoop entered our dorm room, freestyling about the plight of the young Black man. He said, "My Rhodes remain Dusty, blocking my American Dream." I was napping at the time and became so excited when I heard that line, I jumped up and banged my head on the top bunk.

Besides rapping, Snoop was also a pretty good ribber, as he pulled off practical jokes with the greatest of ease. I recall purchasing a Dan Marino Miami Dolphin home jersey on sale as the team had just updated their look; they added a hint of blue to the logo and number outlines, and gave the mascot, T.D. the Dolphin, an angry face. I planned to wear the jersey on Saint Patrick's Day. Snoop thought the jersey was fresh and that I needed to wear it immediately! When I told him I wouldn't, he grabbed it and began running down the hallway with it. Naturally, I gave chase. Once he descended to the second floor, he put it on and yelled to onlookers that he was the Black Dan Marino and that he needed wide receiver help. A couple of times, I got close to him but he would always manage to escape to the stairwell.

By the time the chase ascended to the fourth floor, I had an epiphany of sorts. Snoop had a butter-soft leather coat that was a size too small for me. I went back to our room, grabbed it, put it on and waited for Snoop to see me. When he saw me in his coat he laughed and said, "I don't care about that coat, sha. I'm the Black Dan Marino; I can just buy another!" Dejected, I went back into our room but quickly discovered another option. Snoop was the epitome of a Jordan-head and would buy them on launch day, or would sometimes manage to score them early. He had recently purchased the white/red Jordan XII, which was a size 12, one size smaller than my own. I grabbed one of them, put it on, and went out into the hallway and just waited. Snoop, who was still running around the dorm, saw me, stopped, and said, "Quit playin'! Game over, sha. Dan Marino just retired!"

Snoop never stopped freestyling, but I believe that was the last time he touched an article of clothing that belonged to someone else.

Limited Releases
Beasts from the East

Growing up in the predominately African American neighborhoods of Southeastern Virginia, we—fans not in the know—thought Georgetown was an HBCU (Historically Black College or University) because many of the players (including head coach John Thompson Jr.) were Black. As a result, on the basketball courts of my hometown, it was common place to find a plethora of Georgetown fans. During that time, the Georgetown basketball team had the most wonderful sneakers I'd seen on the court. The earliest I recall were the Nike Terminators. They were specific to the Georgetown uniform with matching hues of blue and gray. Many schools had matching shoes, but it seemed as if the Big East conference had the best-dressed teams, hands down.

In 1996, the Big East powerhouse Syracuse faced Kentucky in the NCAA Division I national championship game. Syracuse eventually lost the game 76-67, but to me, that was not the story. John Wallace, who averaged 22 points a game that season, wore a pair of Nike Air Max Speed Turf on the court! I remember they were a black-and-white colorway and featured a voltage yellow

air unit in the soles. Ironically, they were the same shoes Jim Harbaugh, then quarterback for the Indianapolis Colts, wore in the 1995 AFC Championship game vs. the Pittsburgh Steelers. I later saw them on the clearance rack at a store in the summer of 1996, but passed them up. I live with that regret.

I also remember a game from the early '90s where Seton Hall, coached by Peter J. (P. J.) Carlesimo, went against convention and wore the lycra compression shorts that everyone else wore underneath their shorts, *as* game shorts! The lycra shorts were printed just like Seton Hall's normal game shorts. The announcer mentioned on air that maybe Seton Hall would start a new trend. On second thought, maybe the conference wasn't that well-dressed.

FACETED JEWEL

The technology featured in this shoe has the answer to the US economy and makes you an above-average dancer.
The first twenty-three pairs purchased from Chicagoland retailers include a free tank of gas.*

Corna' Sto'

On the corner of the street,
Summertime heat,
Little kids rush in,
Refreshing drinks and sweets.
Hot peas and butter,
Nearby traffic stutters,
Mail truck parks,
Inches from a gutter.
Boxes go in,
Consumers go in,
No words are exchanged,
Just phony smiles and grins.
There in the backroom,
A simple stockroom,
A land of white tees
And ill-fitting shoes.
Four for twenty, my friend,
And please come again,
Here's an all-white pair,
For your little lady friend.

Black Spending Power

Gives your product credibility,
sets trends.
Will eventually have you marketing toward us,
at which point, we will create another trend.
Can make items from your clearance rack
appear worthy of Rodeo Drive.
Is a rebel without pause—or cause.
Benefits everyone but us.
Every.
Time.

A Rose by Any Other Name

Thicks …
Thick Soles …
Dee Cees …
D.C. Classics …
Dope Boys …
Freshies …
Fatheads …
Flaves …
WMDs …
Uptowns …
The Air Force 1

Sneakerdoodle Recipe

Ingredients

½ cup patent leather

1 cup elephant print innovation

¼ teaspoon 3M reflective materials of desire

¼ teaspoon colored laces

½ teaspoon popular culture

1 large egg

½ cups all purpose flour

4 tablespoons of customer's concerns

Directions

In a mixing bowl, beat and mix all of the ingredients. Then, pour the mixture over the heads of those in charge at your favorite sneaker conglomerate headquarters.

Shawn Hobbs

When students drop by during office hours to ask pertinent questions, I consider it a rewarding experience. I say this because there are countless hours that expire daily without any student dropping by. To my surprise, many of the questions have nothing to do with class.

Some students stop by to seek advice on matters academic and otherwise. Others stop by to schmooze and brownnose. My favorite questions deal with popular culture and general conversation. One of my students aced my class, but he stops by my office to ask questions about Hip Hop culture and how things were during the subculture's Golden Age. One day in the middle of our conversation, he dubbed me a "Hip Hop historian." That comment immediately invoked thoughts of Shawn Hobbs.

Shawn was a tad bit older than the rest of the young men at my church, Oak Grove Baptist. We—the rest of the young men at my church—were of middle school age, and he was in high school. I had plenty of time to learn from him, as the young men of the church all served on the Jr. Usher Board together, and attended the same Sunday school. Shawn was the expert in three of my childhood interests: Hip Hop, sneaker culture (before it was considered a culture), and professional wrestling. You had to be on your Ps and Qs just to be able to hold an intelligent conversation with the guy. Shawn bought every album, whether he liked it or not. Someone would ask, "Shawn do you have—" and Shawn would cut them off and recite every urban release from the last six months.

When it came to sneakers, no one could hold a candle to his collection. During this time, Air Jordans were just becoming status

symbols for your feet, and Shawn walked in luxury. It would take me a few years to get to his level with music knowledge and a couple of decades to grow my kick collection. However, when it came to otherwise useless knowledge of pro wrestling, I could not be touched. I read every periodical there was about the sport. I watched every program. I knew information about wrestlers who worked for promotions that were not televised. When these guys made it to the big time, I would tell my friends all about them before they could hit the ring. My friends would ask, "How'd you know that?" I would think to myself, "Hey, I have to usher next to Shawn on Sunday."

Now that I'm an adult, I think about how reading all of those pro wrestling periodicals and having an acute interest in kicks would prepare me for the rest of my life. I don't know many other professors who would compare and contrast Antigone and Ismene's sibling rivalry with the sibling rivalry betwixt Bret and Owen Hart. By having positive role models like Shawn Hobbs and hobbies such as collecting kicks, I've avoided a plethora of pitfalls—see your local 6 p.m. or 11 p.m. news—that others like me have not been as fortunate to avoid. Shawn deserves credit for helping to spark childhood interests I still enjoy today.

Over the years, I've watched my sneaker collection grow almost as much as my interest in sneakers and the culture surrounding them. I don't think my parents understood how much I expressed myself through my footwear. I'm sure they shared a chuckle or two when I told them I was going to write a book dedicated to sneaker culture. Unfortunately there wasn't much literature dedicated to the culture when I was a child. Our sneaker knowledge came from slick ad campaigns, or word-of-mouth legends that detailed the

intrepid feats of "said" athletes, wearing "said" athletic shoes. After reading Bobbito Garcia's *Where'd You Get Those?*, I wrote this book as a tribute to all individuals who have a passion for sneakers and the culture that surrounds them, as well as a love for poetry and literature. One thing is certain, if you've identified with this book in any way, shape, or form ...

I know you got *Sole!*

Hyperstrike Releases

Like Capitalism:
How Michael Jordan Re-Established Nike while Influencing a Generation that Never Saw Him Play

Within the world of merchandising, one would have a difficult time identifying a more popular, or profitable athlete than Michael Jeffrey Jordan. Over time, Jordan has acquired a cult-like following by utilizing avant-garde marketing that resonates with multiple generations. Generations of admirers have spent hours in their various fields attempting to "Be Like Mike." In the lyrics to "Show Me What You Got," music mogul and popular culture icon Jay-Z rapped, "I am the Mike Jordan of recording; you might want to fall back from recording." His lyrics personify this notion. However, some Jordan followers are as baffled and alienated, as they have been impressed by Nike's marketing and production of the Jordan Brand.

For those outside of sneaker culture, Jordan Brand is a subsidiary of Nike; currently, Nike uses cheaper materials in the manufacturing of their retro sneakers. As a result, the shoes do not fit as they once

did. They also break down quicker with fewer wears. Still, this has not stopped Nike from raising retro shoe prices. In 1988, the Nike Air Jordan Revolution retailed at $100. The 2023 version—now marketed as the Air Jordan III—retails for $200. Consequently, many fans who witnessed Michael Jordan's on—and off—court accomplishments no longer subscribe to the Jordan mystique. The Air Jordan I originally released April 1, 1985. It was retroed in 1994 in a standard Chicago Bulls colorway. It is worth mentioning that by 1994, Jordan was retired and sales were poor. Many of the children who were once Jordan fans were now teens who became fans of players like Anfernee Hardaway and Shaquille O'Neal. By the time they were adults, they'd grown out of the phase. However, a new generation of fans/sneakerheads have emerged and have grown to love and idolize a player who they have never seen play. In short, Michael Jordan re-established the Nike brand while enamoring and influencing the Post-Millennial generation.

In fairness, to begin to understand Michael Jordan as a marketing influence on the Post-Millennial generation, one must consider the marketing influences of a young Michael Jordan. Jordan grew up a big fan of Adidas. Before Nike rose to power, Adidas became an international phenomenon via Olympic handouts and underhanded political moves within the global sport of soccer. Adidas asserted world sneaker dominance while battling Puma. Originally, Adidas and Puma were one brand. It took WWII and political differences to prompt a fall out betwixt Adi and Rudolf Dassler and permanently split the brands—and the Dassler family (Smit 31). Though both companies would go on to garner notoriety and fame, Adidas ultimately became a bigger company; it also became synonymous with popular and Hip Hop cultures.

Surely, Adidas's hold on popular culture influenced Michael Jordan during his adolescent years. Though Adidas was his favorite shoe brand, he wore Converse during his undergraduate days at the University of North Carolina at Chapel Hill. A large portion of Jordan's mystique includes the fact that the Laney High junior varsity Buccaneers cut him from the team. Jordan wore the label of an offensive player from his prep years throughout college. After declaring for the NBA draft as a college junior, Jordan was drafted number three after dominant post players Hakeem Olajuwon and Sam Bowie respectively. No longer an amateur, it was time for Jordan to procure endorsements. Chief among them was a shoe deal. Naturally, Jordan—like many youth today—wanted to wear the most popular brand. "Michael Jordan himself was set on the three stripes, describing himself as an Adidas nut," (Smit 197). Adidas, with a strong influence in the NBA—behind the top brand at the time, Converse—undervalued Jordan's potential. Kareem Abdul-Jabbar was widely considered one of the top NBA players in 1984. Adidas endorsed Abdul-Jabbar and laced him with a signature shoe that would later become the shoe of choice for Hip Hop's B-boy breakdancers. Adidas had a reputation for not breaking the bank when endorsing athletes and many considered it an honor just to wear the brand. Financial journalist Barbara Smit writes, "therefore, it didn't seem too far off the mark when Adidas offered on $100,000 for Jordan, the same deal they had with Kareem Abdul-Jabbar at the time," (Smit 197). Jordan was heartbroken upon receiving the offer.

Undaunted by the diminutive offer, Jordan considered himself an Adidas guy. He still planned to sign with Adidas. His parents begged him to listen to other offers. Converse had a competitive

edge over Nike, as Jordan was already familiar with the brand. But, Jordan's parents wanted him to consider Nike's offer specifically. With reference to Nike, basketball tastemaker Sonny Vaccaro was instrumental in assisting Nike with securing Jordan's services. As a rookie, Jordan signed a lucrative contract with the Chicago Bulls, earning $3 million over five years. At the time, it was the third highest contract for a rookie in the history of the NBA. Super-agent David Falk was determined to secure a plethora of endorsements for Jordan. These endorsements included, but were not limited to, food and beverage, apparel, and athletic shoes.

At the pitch, Jordan was initially unimpressed. When shown images of what would become the Air Jordan I, Jordan quipped, "Ah, the Devil's colors, I wish I was still at Carolina so we could use 'Blue Heaven,'" (Strasser 433). After much ado, Jordan signed with Nike for $2.5 million over five years. At first glance, the numbers appear pedestrian by today's standards. Yet, the deal was a remarkable when one considers what was included. Jordan procured a royalty from not only the Air Jordan, but also all Nike Air basketball shoes exceeding 400,000 pairs. He also garnered a percentage of the net sales of all Jordan apparel and accessories, and some shares of Nike B stock (Strassler 432). At the time, Nike had nothing to lose and everything to gain. They had little cachet among teens and were fading fast in the NBA. Until the Jordan signing, the brand was associated with middle-aged white men who jogged, having gotten its start as Blue Ribbon Sports off the back of Onitsuka Tiger. Attempting to find himself professionally, Phil Knight convinced Tiger to make him an American distributor after lying to them about having his own company.

In a coup, Phil Knight collaborated with his college track coach Bill Bowerman to make advancements in track shoe design. The duo appreciated how Onitsuka produced a cheaper product in comparison to Adidas. However, Bowerman was obsessed with creating a lighter shoe that would remain intact long enough to complete a race. On the subject of Onitsuka designs, "When Onitsuka sent Bowerman his first nylon marathon shoe it was far from the racing spike he imagined," (Strassler 68). Eventually, the muse of innovation visited Bowerman during breakfast; a waffle iron inspired the Nike Waffle Runner. Competitors were amused. Adidas was beside themselves in amusement when they heard that Nike designed shoes with a waffle iron. Slowly but surely, Knight and Bowerman finessed control of American Onitsuka distribution rights. When Blue Ribbon was finally launched, the initial shoes were direct rip-offs of Onitsuka designs. Knight and Bowerman used a common legal loophole. Companies cannot trademark a shoe's silhouette, only its technology.

Respecting technology and innovation in sneaker design, the outdated technologies featured in Air Jordan retros offer a modicum of Michael Jordan's influence on Generation Z. Outside of archaic retros, "Nike themselves have been pushing the boundaries of their designs by pushing a range of hybrid concepts," (King 154). If one were to poll young Jordan aficionados on their favorite Air Jordan retros, many would claim the Air Jordan III or the Air Jordan XI as their undisputed favorites. The technologies featured in both models are prehistoric in comparison to modern basketball sneakers. Though still aesthetically popular today, original colorways of the Air Jordan III and XI sell for hundreds of dollars above retail in the sneaker aftermarket. One could directly

trace Jordan's rise in global popularity to the Air Jordan III; the Air Jordan Revolution is its original name.

The Air Jordan Revolution/Air Jordan III is a takedown model of the Nike Air Revolution. The sneaker industry uses the term "takedown" to describe a cheaper model of a higher-priced shoe. From a non-professional perspective, the Nike Air Revolution is a high-top shoe with more material and technology than the Air Jordan Revolution. In 1988, the Air Jordan Revolution retailed for $100 while the Nike Air Revolution retailed at a modest upcharge of $105. If not for the hiring of Tinker Hatfield, Jordan might have left Nike. After the $105 Jordan II—manufactured in Italy with 100 percent Italian leather—flopped in sales, Jordan lost faith in Nike because the Air Jordan I had also garnered poor sales.

With Nike experiencing employee turnover, Jordan was prepared to bolt to Adidas with his on-court play as the bargaining chip. The design of the Jordan III saved what would become Jordan Brand. Hatfield had an architectural engineering background before Nike hired him. In his former life, he created structural archways instead of carbon fiber arches. Hatfield approached Jordan directly. Looking for feedback, he asked Jordan what he wanted to see aesthetically. Before the Jordan III, Michael Jordan had little input on the design of his sneakers. Jordan requested animal print. This was unusual as most basketball sneakers featured colorways from a team bank—colors that generally matched high school and collegiate team uniforms—until the Jordan III. Before 1988, few professional athletes had a say in their shoe's design. Many considered themselves blessed just to have the opportunity to receive free shoes and a stipend to wear them. Jordan gave input that would revolutionize basketball sneakers forever.

Before the Jordan III, basketball sneakers were largely high-top in height. Consequently, MJ had a novel idea. Tinker Hatfield explains:

> *Michael asked about doing something in between a hi-top [sic] and a low top. He knew it would be great because the shoe would be light and still have a little more stability than a low top. That was a performance thought, and you don't normally get that from an athlete. (46)*

The advancements did not stop there. Hatfield used tumbled leather in the construction of the Jordan III. One day while shopping for furniture, the rich texture of a leather sofa inspired Hatfield; he promptly included the material in design plans. It is known among sneakerheads that Michael Jordan liked to wear a new pair of sneakers for every game. The tumbled leather upper gave the Jordan III an "already broken in" feel. Considering style and performance, Hatfield ditched the prominently featured Wings logo from the prior two incarnations of the Air Jordan. He decided to use what would be eventually named the "Jumpman" logo. Hatfield found the mark in a file of discarded Jordan inspirations. He loved it so much, he added it to the Jordan III without MJ's consent.

Former Los Angeles Laker and Jordan disciple Kobe Bryant coveted the Jordan III. He remarked, "The '88 Air Jordans were probably my favorite ones. The IIIs just because of the style and the cut, and how comfortable it was at the time," (Bengston 72). Fans of Jordan Brand argue the Jordan III is the greatest conceived basketball shoe; it is still a takedown model of the Nike Air Revolution. Both shoes have the same midsole, which in sneaker design, is the most expensive part of the shoe. While shopping, one may notice that many shoes have the same foundation. The

Jordan III is the first Jordan to feature Vis-Air technology; the Air Revolution had it prior.

As a child, Allen Iverson received a pair of Nike Air Revolutions from his mother for his thirteen and under AAU Basketball finals. As a direct result, Iverson's mother could no longer afford to make the scheduled utility payment after purchasing the Nikes. Their home lost power immediately after. When asked about the Nike/Jordan influence, Iverson stated, "I was that kid that wanted the Jordans. I wanted them because Mike was my hero," ("Allen Iverson Goes Sneaker Shopping," 2017). Sneaker companies, however, recognize the earning potential in discontinued models. Newer generations of consumers essentially fall in love for the first time (King 9). A shoe made famous by Jordan Brand association would influence noteworthy Xennials, who would join the ranks of the NBA's elite. It is difficult to find an interview where Iverson does not bestow heavy praise upon Michael Jordan. Ironically, Jordan-influenced players would also influence Generation Z. Allen Iverson may be chief among them.

For the minority of Jordan worshippers who do not pledge allegiance to the Jordan III, it is likely that they tout the Jordan XI as the greatest basketball shoe of all time. The silhouette is immensely popular among Generation Z. Nike has done a great job of keeping Jordan relevant via the mystique of his on-court accomplishments. Although NBA players like Bill Russell and Robert Horry have won more world championships, 11 and 7 respectively, Nike—via shrewd marketing—portrays Jordan as the greatest basketball player who has ever lived. Jordan is not the career leader in any significant statistical category sans career/playoff points per game, yet via a court of public opinion, Jordan reigns

supreme. Members of Generation Z did not have an opportunity to see Bill Russell play, nor did they see Horry. Unlike these men, Jordan's name was on the lips of every footlocker sales associate, every local playground superstar, every paternal figure who wanted to "Be Like Mike," and every maternal figure who wanted to be *with* Mike. Members of Generation Z could experience the '90s via YouTube while being jettisoned back to a time when the retro shoes of today were the state of the art shoes of yesteryear—after hearing of Jordan's exploits and seeing a few images of him in action.

Regarding the other iconic retro Air Jordan Generation Z covets, The Air Jordan XI has its own legacy. Jordan wore the Jordan XI during the 1995-96 season. That year, the Chicago Bulls won the second of three consecutive NBA World Championships. For Jordan, it was his second All-Star game MVP, his fourth regular season MVP, and his fourth NBA Finals MVP. It is noteworthy that the Bulls won a then record 72 of 82 regular season games. Nike will not let society forget this, even though the 2015-16 Golden State Warriors—who won 73 of 82 regular season games—have since eclipsed the record.

Though Jordan won six world championships in six different Jordan models, no Jordan commands as much attention as the Jordan XI. Renaissance man Bobbito Garcia remarks, "The XIs were iconic. I had a pair three months before they came out in 95, and a dude offered me $300 for them. This was long before eBay resellers and all that hoopla," (Garcia 242). The shoe became so popular that it retroed only five years after the initial release; it also prompted Jordan Brand to move retro releases to Saturdays because adolescents began cutting classes and school entirely to

stand in line to purchase Jordans. The Jordan XI resonated with the youth as it epitomized Hip Hop culture. Regarding Hip Hop culture, Allen Iverson's on-court legacy directly relates to the Jordan XI. He wore the shoe on and off court during his sophomore effort at Georgetown University. When asked about Hip Hop's place in the NBA, Iverson quipped, "We all dress Hip Hop. We love Hip Hop; I mean that's just our generation right now," (Burgess 28). Like Hip Hop culture, the Jordan XI does not follow conventional expectations in regard to design. The upper contained Cordura nylon, round laces, and a Jordan-requested patent leather mid-foot shroud. Somehow, it maintained an upscale look while obtaining street credibility. The foundation featured a carbon fiber shank plate. Made famous by Jordan Brand, it is noteworthy that Reebok used the technology first in the Shaq Attack I in 1992.

Technology aside, the Jordan XI resonated with celebrities. R&B super group Boyz II Men famously wore the Jordan XI with tuxedos at the 1996 Grammy awards. Recalling the monumental moment, group member Shawn Stockman asserts:

> *Around 95-96, Jordan came out with the Concord XIs, and when they first came out, Jordan told us that the people over at Nike were not big fans of the XI, initially. Jordan had to convince them that the XIs would be great. He told them that one day an entertainer is going to wear those kicks with a tuxedo or something like that because of the patent leather toe. It makes sense because patent leather shoes are often worn with tuxedos. Lo and behold, the day of the Grammy's the guys and I came out in White Sox baseball caps, tuxedos, and Jordan XIs. MJ saw it and was like, Yo, this is crazy! He was a big fan of the group even before that, so when we*

finally met up with each other, he told us this story. From that meeting, we became really good friends. Since then we've been getting Jordans on the regular because of that. I pretty much have every single Jordan that has come out since that meeting. ("Boyz II Men's Shawn Stockman Talks Air Jordan XI," 2012)

Groups like Boyz II Men have always had a stranglehold on popular culture. Consequently, they are often gifted products—including, but not limited to, sneakers—for placement. Product placement has just as much of an influence on youth as any other form of marketing. Ask a Gen Z-er which film is their favorite, and they may respond with *Space Jam.* Jordan appeared in the film with a cast of "Looney Toons" characters, including Bugs Bunny and Daffy Duck. To date, *Space Jam* is the highest-grossing basketball film of all-time. The film's narrative depicts Jordan as a Harriet Tubman-esque figure summoned by Bugs Bunny to free the rest of the enslaved toons. The only way the toons can earn their freedom is by obtaining a victory in basketball over the Monstar alien team. To complicate matters, The Monstars steal the basketball talents of prominent NBA players of the day—who all happen to be real-life friends of Jordan, or players he repeatedly posterized—Charles Barkley, Larry Bird, Patrick Ewing, Shawn Bradley, Larry Johnson, and Muggsy Bogues. Ultimately, the Toon Squad wins and are freed; the stolen talents are returned to their rightful owners. Regarding plot and narrative, the film is simplistic. However, its true impact resonates twenty-seven years later.

Worldwide, Michael Jordan is still a hero via DVDs and streaming services. Though he can no longer play professionally, in the eyes of Generation Z, he's the champion from the videos, commercials,

and films, as they've only seen him in videos, commercials, and films. To Generation Z, the Monstars might as well be the New York Knicks or Utah Jazz, because they all lost to Jordan repeatedly. *Space Jam* follows a linear path of Jordan's retirement from the NBA and a futile attempt to play professional baseball. In actuality, the Jordan IX is the only Air Jordan that Michael never wore in the NBA during his career. Accordingly, the shoe did not sell as well, as the Jordans released after Jordan returned to the NBA. At the time, Ken Griffey Jr. was the only Nike-endorsed baseball player with a signature shoe; Jordan was no Griffey, Jr. He barely broke the Mendoza line—a baseball expression used to express hitting for at least a 20 percent average—while Jordan played minor league baseball in player-exclusive Jordan IX baseball spikes, but they would not release for retail until nearly a decade later. In a stroke of marketing genius, the Jordan IX procured premiere product placement in *Space Jam*. Members of Generation Z do not know which Air Jordans sold poorly, because sneaker blogs hold them all in high regard. Unfortunately, the most read blogs obtain gifts or financial backing to ensure their authors write favorable articles.

To be honest, if many Generation Z members knew such, it would most likely not matter. Surely, the executives at Nike were betting on that fact regarding future earnings. In today's market, the most unpopular sneaker designs of yesteryear have a second opportunity to sell as retro models. The return is also larger. Companies like Nike do not have to spend as much revenue on advertising and marketing. Members of Generation Z market and advertise free of charge. YouTube contains scores of "unboxing" videos. Shiny, happy Generation Z-ers tell the world the features and price points of various shoes, as they unpackage them on camera. Specifically, this

helps to spread the gospel according to Jordan. An overabundance of teachers, medical doctors, lawyers, architects, engineers, and various professional athletes have all been influenced by Michael Jordan. Much of this derives from shifts in cultural norms. Elizabeth Semmelhack explains, "The importance of sneakers in the male wardrobe increased and became more widespread with the evolution of Casual Fridays in the late 1980s and into the 1990s," (Semmelhack 162). As societal norms changed, sneakers became a staple in work and leisure wear; it did not matter the occasion. Finally, the difference between those who became teachers, medical doctors, lawyers, architects, engineers, and various professional athletes and Generation Z is that the latter has never seen him play.

Sadly, though the societal norms concerning acceptable dress have changed, it is noteworthy that Jordan Brand has overproduced retro Jordans ad nauseam. The act has had an effect on the entire footwear industry as a result. Karl Marx warned of this act via his teachings:

> *Overproduction is the sudden recall of all these necessary moments of production based on capital; their neglect therefore brings a general depreciation in value. At the same time capital has the task imposed of it of beginning from a higher stage of the development of productive forces, etc. and renewing its search with a consequent ever-greater collapse as capital. It is therefore clear that the higher the development of capital, the more it appears as a barrier to production, and therefore to consumption, quite apart from the other contradictions which make it appear as a burdensome barrier to production and commerce. (McLellan 399)*

If Jordan Brand would like to continue to perpetuate the urban legend that has become Michael Jordan, they might want to slow

down on the production of retro Jordans. If not, Generation Z may go the way of the Millennials and select cheaper shoes or brands that are not overproduced. Until the ceiling collapses, Jordan is still who Nike says he is.

Currently, Jordan's influence is as strong as it was in the '80s and '90s. Via the magic of YouTube, swift marketing schemes, vanguard sneaker conception and design, and urban legend, Michael Jordan re-established the Nike brand while enamoring and influencing the Post-Millennial generation. Twenty years post his retirement, children, tweens, teens, and young adults *STILL* want to "Be Like Mike."

Boom B.A.P. VI

What are they all wearing?
It is time to look
Scan the Explorer page
Log in to Facebook
You spy Blanco y Noir
Superstar and Huarache
You opt not to swap laces
You opt to photocopy
No thoughts of your own
Plagiarizing "style"
Replicating your last lover
When you dress your child

Midsolesdontcrack.com

The ship is sinking;
you are still posting.
Your grails are at the outlet;
you are still boasting.
Retail price: $189.99
Walmart.com price: $79.99
The ship is sinking,
as you play your violin.
You wear cracked-ass midsoles,
with your blind-ass friends.

Collaboration

When you can't sell another pair—
When the youth no longer care—
When the elders become too cheap—
When the heat rises beneath your seat—
When the material begins to wear—
When tempers start to flare—
When things go bad—
It's time to collab.

Dating Sneakerheads

Ha! You expected this work to contain insight.
Don't fall for the banana in the tailpipe.

You Fit the Description

You fit the description
Because you are **Black** AF,
There are sneakers on your feet
And rims on your truck.
You look **ANGRY**
Like you just might attack,
I just called for backup
To help give you some flack.
Where are you going?
Not on this side of town.
I will tell you
Where you are going,
FACE DOWN ON THE GROUND!
How dare you talk to me
In such a respectful tone?
Take these "four" your troubles
Gunshots to your dome.

Fifteenth Anniversary Poems
Ailuropoda Melanoleuca

Masses march in sync,
Identical steps and kicks,
Lost in sameness's grip.

Karl's Jr.

In the year 2023, where sneakers clone, a tale of struggle, and class unknown. In the realm of sneaker culture's domain, lies a Marxist critique, one shall explain.

The proletariat, toiling in despair, dreams of liberation, their burdens to bear. Yet within the realm of sneaks, so grand, a system emerges, unseen by the hand.

General releases, they come to pass, accessible to all, the working class. But alas, the aftermarket reigns supreme, exploiting the masses, crushing their dream.

Commodified desires, the bourgeoisie's delight, exorbitant prices, a never-ending plight. The sneakers once for all, now exclusive, rare, creating divisions, as profits they ensnare.

The proletariat, lured by the craze, yearns for the symbols, as culture displays. But the aftermarket's grip, it holds them tight, drowning them in debt, extinguishing their light.

Karl's Jr.'s Expansion Pack

In the Struggle for sneakers, they find no gain, just false hope and hardship, their efforts in vain. Their surplus value, extracted in a snap, as the bourgeoisie profits, watch the proletariat collapse. But fear not, comrades, for there's hope to find, solidarity, unity, a path intertwined. Reclaim the means of production, we must, from the grip of capitalism's unjust trust.

Collective ownership, the proletariat's plea, for sneakers to be shared, and all to be free. No longer exploited by aftermarket's might, the working class rises, reclaiming their right.

Now, let us awaken, to the chains that bind us, no longer forsaken. Sneaker culture reimagined, a Marxist dream, where the working class triumphs, in their collective scheme.

THE MONGOL EMPIRE

They buy many shoes
Hoping to make a fortune
But no one wants them

They lower the price
Still no buyers in sight
Their debt keeps growing

They sell their own pair
The last ones they had
They moved in with bae

11368

In the bottom of the 9th, a moment so grand, a shortstop took off, stealing with demand. The game televised on TBS, the stage was set, a daring theft of 3rd base, a moment not to forget.
His team trailing, hopes hanging by a thread, he dashed like lightning, down the line he sped. The crowd erupted in cheers, signature spike in the air, as he slid safely, victory within his snare. With that stolen base, key to the game won, the National League pennant claimed, upon the winning run. Cameras focused, capturing his jubilant grace. A hero emerged, glory upon his face.

Three the Yard Way

From Bronx to the world
Hip Hop tells stories of life
Fifty years of beats

Hip Hop breaks barriers
Inspires generations
Cultures of the globe

Hip Hop and sneakers
A match made by divine
Style, art, and music

Who Cares?

Not the American Multinational Corporation
Not the designer
Not the marketer
Not the signature athlete
Not the manufacturer
Not the retail chain
Not the influencer
Not the crush
Not the Algebra II teacher
Not the big box discounter
Not the single parent (returning from 3rd shift)
Not the assailant (crouched behind the 2009 Altima)
Not the ER surgeon
Not the mortician
Not the pallbearer
Not the pastor
Not you.

THE QUESTION REMAINS

How long will you be down for the culture?

Who Sold You That Jank?

Who sold you that jank?
The real question is: Why?
Because it is clear to us
That you are not that guy
And to keep it 100
You're not even that girl
Matter of factly speaking
In this Inclusive world
Thus, you are not that person
Quiet as it is kept
You are not real
And your kicks are reps
So, who sold you that jank?
You don't have to lie
This is a safe space
Yet, the question is: Why?

"Well, That's Too Damn Bad!"

I don't like the current trends and practices in marketing and manufacturing, Grandpa.

IF SHE LOVES LEOPARD PRINT

If she loves leopard print, she has low blood iron
Test the hypothesis to see if I am lying
Legging, skirt, bodycon dress, or blazer
The world is no opponent
But, air conditioning will phase her
Leopard print is in her DNA
She pounces on the day like a cat
The rosettes on her apparel
Blend her with a natural habitat
She marks her territory with scratches
And scents and stones
You can tell she's solitary
By the sneakers she has on

Chicos, Adios!

No me importa tu sonrisa
ni tu forma de hablar
no me importa tu camisa
ni tu perfume de azahar

Lo que me importa es tu calzado
que no tiene nada de encanto
esas zapatillas tan gastadas
que parecen de otro año

No quiero salir contigo
ni tomar un café
no quiero ser tu amiga
ni tu novia tampoco, ¿qué crees?

Busca otra que te aguante
tu falta de estilo y buen gusto
yo prefiero quedarme sola
que andar con alguien tan injusto

If It Ain't Broke ...

There once was a sneaker designer
Who had no idea how to make them finer
He copied the old ones
With some minor changes
When he died
They put him on a mural

LITTLE BIG BROTHER

Man, you've been a stranger
I haven't seen you in a while
How is your wife?
What? You're on your THIRD child?
Nah, you're the one with all the money
An entrepreneur laying tiles
We're so proud of you around the way
I told Zay about you today
I told him, you're the neighborhood hero
The number 1 Chief Rocka
Maneeee, let me hold something
And give me a ride to Foot Locker

What, to the Unemployed, Is a Labor Day Sale?

What, to the unemployed,
Is a Labor Day Sale?
Is it a time or space
To frivolously spend?
Or is it an opportunity
To chase the latest trend?
Is it a chance
To perpetrate a fraud?
Or is it the day
To tell that #$%@
To get a job?

Works Cited for "Like Capitalism"

"Allen Iverson Goes Sneaker Shopping with Complex." *YouTube*. YouTube, 10 Apr. 2017. Web.

Art & Sole: Contemporary Sneaker Art & Design. N.p.: Laurence King, 2012. Print.

Bengtson, Russ. "Encore Still Waiting for Your First Look at the Zoom Kobe 2." *Slam Magazine Presents: Kicks* n.d.: 71-72. Web.

"Boyz II Men's Shawn Stockman Talks Air Jordan 11, MJ & Group's Stance on Today's Style." *Nice Kicks*. N.p., 02 Oct. 2012. Web.

Burgess, Zack. "The Infamous: Allen Iverson Has a Real Attitude Problem. Yours." *Slam Presents: Iverson* n.d.: n. pag. Web.

Garcia, Bobbito, Elizabeth Semmelhack, Emanuele Lepri, Pauline Willis, Dee Wells, Tinker Hatfield, Eric Avar, and Ada Hopkins. *Out of the Box: The Rise of Sneaker Culture*. N.p.: Skira Rizzoli, 2015. Print.

"JAY-Z – Show Me What You Got." *Genius*. N.p., 21 Nov. 2006. Web.

Marx, Karl, and David McLellan. *Capital: An Abridged Edition*. Cornelius: Oxford UP, 2008. Print.

Rizzo, Johnna. "On Aristocracy." *Newsweek Special Edition: Jordan* n.d.: 46-47. Print.

Schwarden, Abe. "Air Jordan III Nothing Was The Same." *Slam Kicks Presents Jordans* n.d.: 42-48. Web.

Smit, Barbara. *Sneaker Wars: The Enemy Brothers Who Founded Adidas and Puma and the Family Feud That Forever Changed the Business of Sport*. N.p.: Harper Perennial, 2009. Print.

Strasser, J. B., and Laurie Becklund. *Swoosh Nike: The Unauthorized Story of Nike and the Men Who Played There*. N.p.: Harper Perennial, 1993. Print.

Swarden, Abe Swarden. "Air Jordan III Nothing Was The Same." n.d.: n. pag. Print.

About the Author

Dr. Jemayne Lavar King, a native of Franklin, Virginia, is a 2017 TEDx speaker finalist and a member of Sigma Tau Delta English Honor Society, and Delta Epsilon Iota and Delta Alpha Pi Academic Honor Societies. King's first poem, "Richard Morgan Flier," was published in 2002, followed by the books *Sole Food: Digestible Sneaker Culture, Life Within the Dorm and Other College-Related Poems, Managing Relationships: Bridging the Communication Divide, 20 First Dates: The Poetic Mixtape,* and *The New York Mets in Popular Culture.* King's Chapter, "Straight Up NYC, Like a Mets Fitted: How The New York Mets Influenced Hip Hop Music and Culture," is archived in the Cooperstown National Baseball Hall of Fame and Museum.

King is the creator of the world's first collegiate English course dedicated to Sneaker Culture literature and identification within Sneaker Culture. Dr. King holds a Bachelor of Arts in English/News Media from Elizabeth City State University, a Master of Arts in English Literature from Virginia State University, and a PhD in English Literary Criticism from Indiana University of Pennsylvania. In 2014, King became an ambassador for the American Heart Association, when he won the organization's Lifestyle Change Award.

Serving via lifetime membership of the Elizabeth City State University and Virginia State University National Alumni

Associations, King is also a member of the United States Press Association, and the National Association of Black Journalists. In 2018, he became the thirty-fourth recipient of Johnson C. Smith University's highest pedagogical honor, the Par Excellence Teaching Award. His scholarship is recognized domestically and internationally by entities including, but not limited to, The White House, *The Wall Street Journal*, *The Boston Globe*, *The Philadelphia Inquirer*, *The Charlotte Observer*, *ESPN*, *ESPN+*, and Paris, France's *66 Minutes*, via the M6 Network.

www.ingramcontent.com/pod-product-compliance
Lightning Source LLC
LaVergne TN
LVHW052101090426
835512LV00036B/3037